SECRET ISLE OF WIGHT

Andy Bull

Acknowledgements

The author and publishers would like to thank the following people/organisations for permission to use copyright material in this book: the Wellcome Collection for images from its archive, plus the many photographers who have made their work available under Creative Commons. We would also like to thank Gordon Child for permission to use his picture of Augustus Bull's shop in Wroxall, and to acknowledge Ray Girvan's fascinating JS Blog, which provided many leads for my research.

Every attempt has been made to seek permission for copyright material used in this book. However, if we have inadvertently used copyright material without permission/acknowledgement we apologise and will make the necessary correction at the first opportunity.

This book is dedicated to all descendants of James Bull (1770–1826) and Jenny Hobbs (1771–1838) of Wroxall, and the Abbott, Holdaway, Linnington and all other related families.

First published 2022

Amberley Publishing
The Hill, Stroud
Gloucestershire, GL5 4EP

www.amberley-books.com

Copyright © Andy Bull, 2022

The right of Andy Bull to be identified as the Author of this work has been asserted in accordance with the Copyrights, Designs and Patents Act 1988.

ISBN 978 1 3981 0522 5 (print)
ISBN 978 1 3981 0523 2 (ebook)

All rights reserved. No part of this book may be reprinted or reproduced or utilised in any form or by any electronic, mechanical or other means, now known or hereafter invented, including photocopying and recording, or in any information storage or retrieval system, without the permission in writing from the Publishers.

British Library Cataloguing in Publication Data.
A catalogue record for this book is available from the British Library.

Origination by Amberley Publishing.
Printed in Great Britain.

Contents

	Preface	4
1.	A Sovereign Isle	5
2.	Great Inventions from the Isle of Wight	15
3.	Rocking the Island	26
4.	Three Remarkable Scientists	37
5.	A Secret Royal Estate, and the Grave of a Forgotten Princess	50
6.	Appuldurcombe and the Worsleys	61
7.	Faith on the Isle of Wight	73
8.	The Island's Great and Good	85
	Bibliography	95

Preface

When I was aged about seven, my granddad Charlie told me stories of the Isle of Wight. My favourite was the one about how, when he was around my age, he and a pal used to creep into the grounds of Queen Victoria's house and watch her being wheeled around the gardens in her bath chair. This wasn't at Osborne House, he told me, but at another house she owned – a secret one.

Granddad Charlie knew how to tell a good story, and I've never forgotten this and his other tales of the island: about a tragic young princess who died aged fourteen and whose grave was forgotten for 143 years, and of life below stairs at Appuldurcombe House.

My family lived on the Isle of Wight, mainly at Wroxall, from at least 1770, so it has been a real pleasure to dig into the stories I was told as a child, and to discover other fascinating, little-known aspects of island history.

The Wight has been a place of remarkable ingenuity and industry; home to a string of brilliant firsts and inventions. Marconi created the world's first radio station here, ushering in the age of instant global communications. Yet much island innovation has been overlooked, or forgotten, by the wider world.

Islanders have never been afraid to think big, as was shown in 1969 when Ray Foulk, the twenty-three-year-old owner of a small island print works, managed to persuade Bob Dylan to play the Isle of Wight Festival rather than Woodstock.

There are also little-known stories about famous island residents. The architect John Nash's role in shaping the face of modern London – designing Buckingham Palace, the Marble Arch and Regent's Park – is very familiar, but his work on the island, and the story of the two remarkable Gothic homes he built here, is almost completely overlooked.

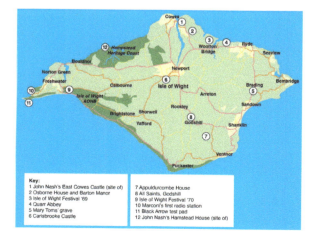

Key:
1 John Nash's East Cowes Castle (site of)
2 Osborne House and Barton Manor
3 Isle of Wight Festival '69
4 Quarr Abbey
5 Mary Toms' grave
6 Carisbrooke Castle
7 Appuldurcombe House
8 All Saints, Godshill
9 Isle of Wight Festival '70
10 Marconi's first radio station
11 Black Arrow test pad
12 John Nash's Hamstead House (site of)

1. A Sovereign Isle

The Isle of Wight has always been a place apart, and not just because it is physically divided from the British mainland by the waters of the Solent. For much of its history this has been a sovereign isle, with its own autonomous rulers including – at one point – a queen. Until 1293 it was held by the de Redvers family until sold to the Crown. The belief in some quarters that this was a fraudulent transaction has fed a desire for independence or, at the very least, a greater say over how the island is governed, that stretches down to the present day.

A Saxon Kingdom and a Norman Independent Sovereignty

The island's independent status goes back to the departure of the Romans from Britain in the fifth century. In *Autonomy and Englishness on the Isle of Wight* Adam Grydehøj and Philip Hayward say: 'After the withdrawal of the Romans, the island fell under the control of a group of Jutish colonists from Northern Germany and was effectively an independent territory until AD 685, when it was forcibly acquired by the Kingdom of Wessex.'

After the Norman conquest of 1066, the island was given by William the Conqueror to his trusted ally William FitzOsbern, who had fought alongside him at the Battle

William the Conqueror with allies including William FitzOsbern, Lord of the Isle of Wight.

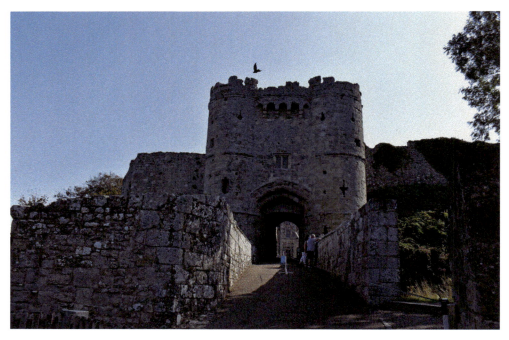

Carisbrooke Castle, established by William FitzOsbern.

Carisbrooke Priory, founded by William FitzOsbern. (John Armagh under Creative Commons)

of Hastings. FitzOsbern was made Lord of the Isle of Wight, and held the land as an independent sovereignty.

> **DID YOU KNOW?**
> The Isle of Wight is known as Dinosaur Island because it is one of the richest areas in Europe for the discovery of prehistoric remains. The greatest researcher into what he called 'old dragons' was William Fox, a nineteenth-century amateur palaeontologist and dinosaur hunter who discovered more species, and as a result has more species named after him than anyone else in Britain. Walking the shore from his home at Brightstone in west Wight, he discovered species including *Polacanthus foxii*, armour plated and with a spiky spine, and *Hypsilophodon foxii*, a fast-running, two-legged, sharp-beaked herbivore.

He built Carisbrooke Castle as his main residence, and also founded Carisbrooke Priory. He was entrusted with subjugating the west of England, and built many other castles across the west country and Wales. Such was his central role that, when William returned to Normandy in 1067–68, he left his army in England under FitzOsbern's command.

On FitzOsbern's death in 1071, his son Roger Fitzwilliam took over his English estates, but unwisely conspired against William and, in 1075, forfeited his estates and spent the rest of his life in prison.

When Henry I came to the throne in 1100, he gave the Lordship of the Isle of Wight to Richard de Redvers, one of his most trusted advisors. For almost 200 years the de Redvers family's position as hereditary lords allowed them considerable autonomy, and they ruled the island as a semi-independent feudal fiefdom.

The Queen of the Isle of Wight

The island stayed in the de Redvers family until 1293 when, on her deathbed, Countess Isabella de Fortibus, also known as Izabel de Forz and, informally, as the Queen of the Isle of Wight, was persuaded – or forced – to sell it to Edward I for 6,000 marks or around £4,000, the equivalent of £5 million today. After this the Lordship became a royal appointment.

The countess had been preyed upon since being widowed in her twenties and becoming one of the richest women in England. In the 1260s her annual income from her estates, including those in southern England inherited from her brother, was £2,500, equivalent to £2.5 million today according to the Bank of England's inflation calculator. Such wealth meant she was targeted by several ambitious and powerful men. Among them, in 1264, was Simon de Montfort (second son of Simon de Montfort, 6th Earl of Leicester). She refused to marry him and fled Carisbrooke Castle, hiding in Breamore Priory near Fordingbridge in Hampshire, among other places.

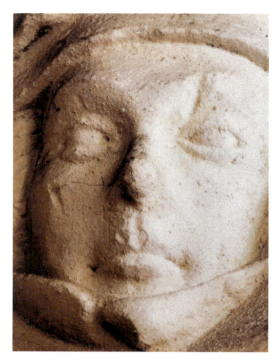

Countess Isabella de Fortibus, represented in a corbel at Breamore Priory.

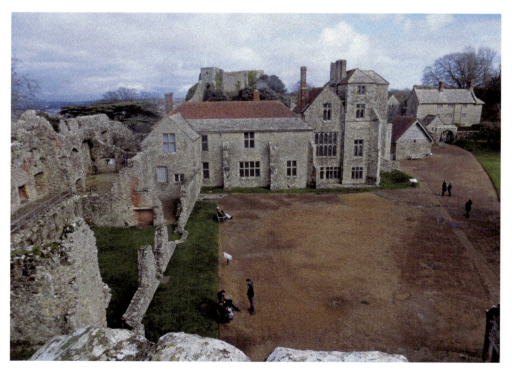

Countess Isabella lived at Carisbrooke Castle.

The Isabella window at Carisbrooke Castle, named after the countess.

Four years later she was targeted by Edmund Crouchback, son of Henry III, but she escaped his clutches as well. Her daughter Aveline was not so lucky, and married Edmund as a child bride in 1269. However, if Crouchback hoped thereby to inherit the Isle of Wight he was to be disappointed. Aveline died before her mother, aged just fifteen, as did all five of the countess's other children.

The sale to Edward I is considered highly questionable by some historians, and many islanders. In 1293 the king, who had been trying to buy her estates since 1276, had reopened negotiations, but Isabella was taken gravely ill at Lambeth while travelling home from Canterbury. Edward sent his servant Walter Langton to her and, while she was dying, had her sign a charter to confirm the sale of the Isle of Wight to the crown. The countess died on 10 November, aged fifty-six, and was buried at her former sanctuary, Breamore Priory.

From 1293 the island had the status of a Crown dependency, the monarch being represented on the island by a governor, a royal appointee, until 1955. The belief that the sale was invalid, and that the island was stolen from its true queen by the conniving king over the Solent, has persisted down the ages.

The King of the Isle of Wight?

It may be that, for a short period, the Isle of Wight had its own king: Henry Beauchamp. Beauchamp had been the boyhood companion and playmate of Henry VI. In 1444, Henry is said to have made Beauchamp King of the Isle of Wight, personally placing the crown on his head at a coronation designed to elevate his childhood friend to a standing closer to his own.

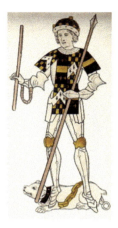
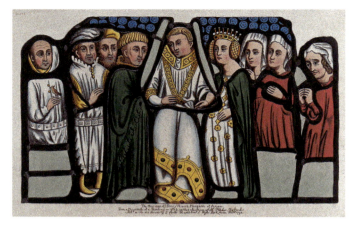

Above left: Henry Beauchamp, who may have been appointed King of the Isle of Wight.

Above right: Henry VI, in a representation of his wedding to Margaret of Anjou. (Wellcome Collection)

The following year he made Beauchamp Duke of Warwick, second in rank only to the Duke of Norfolk. Both appointments caused consternation among the nobility, and especially for Humphrey, Duke of Gloucester, Henry VI's uncle and holder of the island's lordship at the time. It was argued that there was nothing in English law to allow for the appointment of a king of the Isle of Wight.

It seems that Beauchamp never set foot on his 'kingdom' before his death in 1446, aged just twenty-one. He left a widow and an heir, two-year-old Anne, but both titles died with him, as neither could pass down the female line. The tale of his crowning, however, is considered unhistorical by many authorities.

The island was briefly included as part of Hampshire when the first county councils were established in 1888, but a Home Rule campaign on the island led to a separate county council for the island being established two years later. Under the local government reforms of 1974, it was planned to demote the island to a district under Hampshire County Council, but a change of heart at the final hour saw the county status remain. The only administrative overlap with Hampshire today is the police service, Hampshire Constabulary.

DID YOU KNOW?
Among the young ladies who attended Upper Chine School in Church Street, Shanklin, were Diana Dill, who married the Hollywood star Kirk Douglas, and whose son Michael Douglas carried on the family's movie-star tradition, and Jane Birkin, who achieved notoriety in 1967 when her erotic duet with partner Serge Gainsbourg, '*Je T'Aime ... Moi Non Plus*', was banned by the BBC. Jane described her time at the school as 'Dull, dull, very dull'. Upper Chine merged with Ryde School in 1994 to become Ryde School with Upper Chine.

Independence Movements: The Vectis National Party

In 1967, the belief that the 1293 sale of the island was illegitimate led to the foundation of the Vectis National Party. The party wanted the island to be granted Crown Dependency status, which applies to the Isle of Man, Jersey and Guernsey, making it a self-governing possession of the Crown, with its own head of government, called the chief minister, and legislative assembly. Ryde councillor R. W. J. Cawdell stood as the party's parliamentary candidate at the 1970 general election. He achieved only 1,607 votes, 2.8 per cent of the total.

During the postal strike of January to March 1971, the Vectis Party organised an intra-island postal service, with Cawdell as chief post master, and issued two different 5p stamps for local deliveries. At the height of the service, around 1,500 letters and parcels were delivered a day.

Vectis campaigned for a dedicated radio station for the island and a regional television service. Failure to gain widespread support led the party to disband in the mid-seventies.

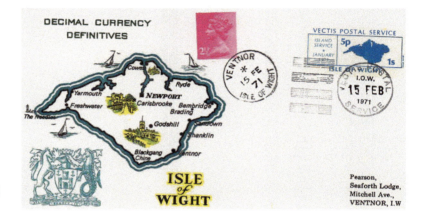

During the 1971 strike, the Vectis Postal Service delivered islanders' letters.

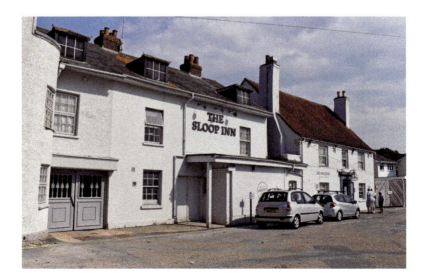

The Sloop Inn, where Lauri Say first performed 'UDI for IOW'.

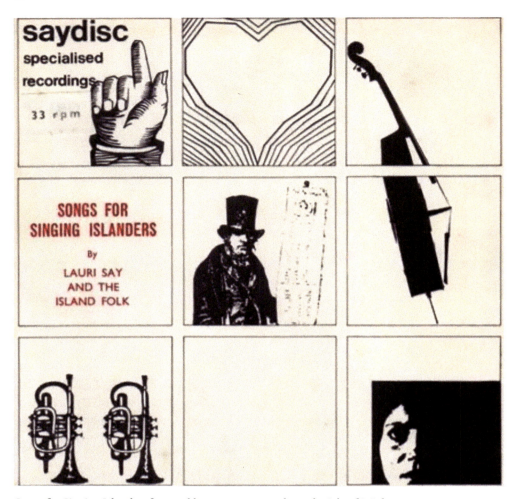

Songs for Singing Islanders featured humorous songs about the Isle of Wight.

Songs for Singing Islanders

Some who supported independence looked to the then British colony of Rhodesia, now Zimbabwe, where Prime Minister Ian Smith had issued a Unilateral Declaration of Independence (UDI) in 1965, in response to Britain's refusal to grant independence while the country was ruled by a white minority.

For many islanders, independence was to be taken with a pinch of salt. Lauri Say, a college lecturer and folk musician wrote a satirical song, 'UDI for IOW', which was released in 1968 on an EP (extended play 7-inch vinyl disc) entitled *Songs for Singing Islanders*. The first verse suggests:

> Down in sunny Africa, things are getting tough
> Because of the behaviour of a man called Ian Smith

Now, you may think he's a traitor
Or you may think that he's right
But we could follow his example on the Isle of Wight!

However, by the last verse, the economic folly of the idea is made clear:

We'll have mounds and mounds of seaside rock
And nobody to buy 'em
They won't need to send the troops in
They'll just sit and bide their time
And when our economy at last begins to crack
Then we'll ask the British Government to take us back!

Lauri Say performed the song at the Island Folk Song Club, which was held every Friday in the Old Boathouse at the back of the Sloop Inn at Wootton Bridge. The initial pressing of ninety-nine sold out at the club the first night they were available, and it went on to sell thousands of copies locally.

> **DID YOU KNOW?**
> Raymond Allen, creator of the timeless seventies sitcom *Some Mothers Do 'Ave 'Em*, still lives in the house in Ryde where he was born in 1940. The show, which starred Michael Crawford, and ran from 1973 to 1978, achieved audiences of 26 million. Raymond was a cleaner at Shanklin's Regal Cinema when inspiration for the show hit him. He told *Island Echo*: 'When I'd clean the steps of Shanklin cinema, a strange little local man would point to a poster and say "What's that film about ... is there any violence in it?" I used his name, Frank Spencer, for the character'.

The other songs on the EP show the spirit in which the lyrics of 'UDI for IOW' should be taken. 'The IOW for Me' teases islanders for their nosiness, the *Isle of Wight County Press* newspaper for its Tory leanings, and the snootiness of residents of Bembridge and Seaview; 'The Southern Vectis Bus Song' is about the unreliability of the island's bus service; and 'The Hovercraft' is about the deafening noise from the allegedly 'super noiseless' Westland SRN hovercrafts then 'screaming across the Solent' to Southampton.

Independence Movements: The Isle of Wight Party
A second independence party, the Isle of Wight Party, was formed by Phil Murray in 2001, partly inspired by the European Union's goal of giving aid to deprived areas in member states.

Its manifesto declared that the party had been founded to champion 'special island needs'.

Among those needs, according to the party, was for a bridge or tunnel to connect the island with the mainland, and they hoped to get the EU to pay for one. The issue of a fixed link was widely debated, but Murray was swimming against the tide of opinion on the island. Standing at the 2001 general election he achieved just 1,164 votes, 1.83 per cent of the constituency vote.

In 2006 Ray Stokes attempted to revive the Vectis National Party, representing a strand of nationalism that opposed a fixed link. The party wanted devolution, but warned of the major demographic changes that would 'inevitably' follow the establishment of a bridge, saying:

> A new bridge will spell the death knell for the Isle of Wight which will bring an overspill area for the South of England making way for an increase in urban housing on a scale that will quickly destroy the culture and character of the island forever.

The party advocated establishing the island as a tax haven, along the lines of the Isle of Man, which it again saw as a model for what the Isle of Wight could achieve. The right of residency would be limited to those who could prove they had lived on the island before independence. All newcomers would have to provide proof of sustained employment on the island, or provide either wealth or new industry to the island economy.

The party was committed to upholding the 'slower pace of life than the mainland', which it saw as 'one of the island's biggest assets'. Tourists would still be welcome, and could continue to 'enjoy the peace and quiet life which is virtually extinct on mainland England'.

Under the plans, which were never tested at an election, the island would have its own currency, stamps and car registrations. In politics, it was hoped the established British party politics would be replaced with a system in which local politicians could 'develop a sense of belonging and a pride in their island'.

2. Great Inventions from the Isle of Wight

A few hundred miles above the earth a little, forgotten piece of Isle of Wight history is looping the globe in a polar orbit. This speck of metal, launched on a rocket built on the island, is the satellite Prospero. It measures just 5 feet across, is shaped like a pumpkin, and has been lapping the Earth every 103 minutes since 1971.

Prospero is the last surviving element of the British race for space, and is just one example of a series of remarkable inventions, technological innovations and ground-breaking industrial achievements that have their roots on the Isle of Wight. The roll-call includes the jet fighter plane, the hovercraft, electric-powered vehicles, world speed record-breaking boats and cars, the jet ski, and the largest aeroplane ever conceived.

Yet the inspirational islanders, and pioneering island-based businesses that created these advances, seldom get the credit they deserve.

The Isle of Wight's Role in Britain's Space Race

Prospero was not only the first satellite to be launched by a British rocket – the remarkable Black Arrow – it was also the last. Even as Prospero was being transported to its launch site in Australia, the British space programme was cancelled, making the UK the only nation to develop a satellite launch capability and then abandon it.

A model of Black Arrow. (artq55 under Creative Commons)

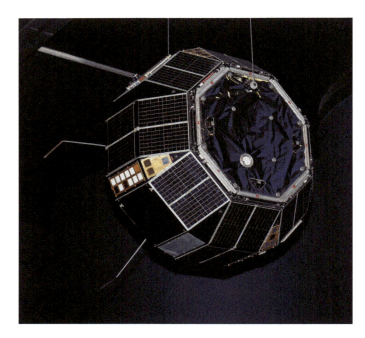

A Prospero satellite replica at the Science Museum.

The Isle of Wight's role in rocket and satellite technology began in the fifties when the government decided that Britain needed its own, independent medium-range ballistic missile programme, and commissioned Blue Streak. The rocket on which Blue Streak was to be launched into space was called Black Knight, and was manufactured at the Saunders-Roe Aircraft factory in East Cowes. Work began in 1955 and the initial launch was at Woomera, South Australia, in 1958, the first of twenty-two.

When that project proved a success, the government decided on an additional project, to develop another rocket, Black Arrow, designed to put small satellites in low earth orbit. Manufacture began in 1964, the same year Saunders-Roe merged with Westland. The two-stage rockets were built by Westland at their factory in Ferry Road, East Cowes, currently home to GKN Aerospace, and the fuel tanks made at the Columbine Hangar in nearby Castle Street, now home to the Wight Shipyard Company. Prospero itself was built by the Royal Aircraft Establishment in Farnborough.

Black Arrow's engines, manufactured in Warwickshire, were test-fired at the Isle of Wight's rocket test pad, above the Needles at High Down, now owned by the National Trust. Exhaustive tests were carried out at High Down, and culminated in replicating the firing of the engines for thirty-five seconds. The only difference between the test and an actual launch was that the rocket was clamped to the gantry, preventing lift-off.

Five rockets were developed – named from R0 to R4. The one that successfully launched Prospero was R3. The final R4 rocket was never launched, and is now in the Science Museum in London. The project was cancelled because the astronomical cost of the Black Arrow programme was deemed to be an unnecessary expense when American Scout rockets could do the job more cheaply.

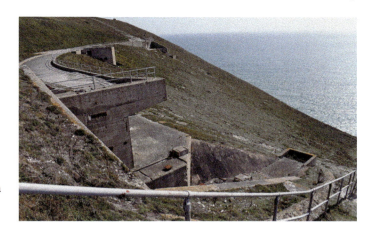

Remains of the High Down rocket test pad, above the Needles.

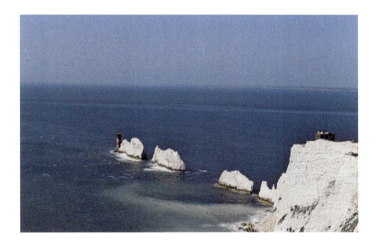

The Needles, where Black Arrow rockets were tested.

In some ways, the British satellite programme was ahead of its time. In the seventies there was a very limited market for such small, low-orbit satellites, which could carry limited equipment. Prospero carries instruments that can detect micro-meteorites in low-Earth orbit. Today, however, the position is very different. With the miniaturisation of technology, it is now possible to launch powerful tools into space on light, low-orbit satellites.

A Scottish company, Skyrora, is currently building a rocket of its own, with a hydrogen peroxide-fuelled propulsion system very similar to the innovative one used on Black Arrow, and plans to use it to launch satellites from the UK. Skyrora has also recovered the first stage of the R3 rocket, which crashed back to earth 150 miles from the launch site – where it lay for years covered in graffiti including 'Putin did it better' – and brought it back to its HQ at Penicuik, near Edinburgh. It is planned to display it at air shows and in museums. There is also a full-size replica of Black Arrow at the Wight Aviation Museum, at Sandown Airport.

Terry Brook, a former fitter on Black Arrow, told Tom Chivers of *Air and Space* magazine: 'The men who assembled the rocket in that Isle of Wight workshop are the forgotten ones, and a great chunk of British expertise has been lost.'

> **DID YOU KNOW?**
> Two pioneering Wight companies created forerunners of jet skis – which they called water scooters – in the 1960s. The East Cowes shipbuilders J. Samuel White produced the GRP Ski-ter, the exposed propeller of which rendered it of questionable safety. Wight Plastics created the Dolphin. Neither were commercially successful, but in 1972 the Japanese Kawasaki company successfully launched their jet ski.

And Marlene Irving, who worked on the static firings, said theirs was a shoestring operation that has been largely forgotten: 'The rocket fuel used to come over on the car ferry; health and safety eat your heart out. There's a museum of sorts, but I meet people who've lived their whole life on the island, and they don't know anything about it.'

The High Down test facility remains, however: a reminder of a time when Britain, and in particular the Isle of Wight, was at the forefront of rocket and missile technology.

Fighter Jets

In 1952 Saunders-Roe went into the fighter jet business. First it developed the experimental Saunders-Roe SR.53, a combined rocket and jet-propelled plane specifically designed to intercept attacking aircraft. However, the high fuel consumption of the rocket engines, and the lack of onboard radar, limited the plane's usefulness. So, in 1955, it developed an advanced turbo-jet-powered version of the plane, the SR.177, for use by both the Royal Air Force and Royal Navy. It could fly at Mach 2.35 (1,785 mph) and climb to 70,000 feet in just three minutes fifty-one seconds.

The Ministry of Supply, responsible for ordering equipment for all three defence services, was impressed, and funded the production of an initial batch of twenty-seven aircraft, the first to be delivered in January 1958. The German government, rearming following the Second World War, also showed an interest in ordering 200 SR.177s.

The lack of a suitable runway on the Isle of Wight meant that, for test flights, the planes had first to be transported to the mainland, to Boscombe Down in Wiltshire.

However, as with Black Arrow, a change in government policy scuppered the project, just as success appeared to be in sight. An MoD defence review concluded that the development of ground to air missiles would make fighter aircraft obsolete. Today it is clear that that is not the case, but the SR.177 was doomed and, on the Isle of Wight, 1,470 highly skilled aircraft engineers were thrown out of work.

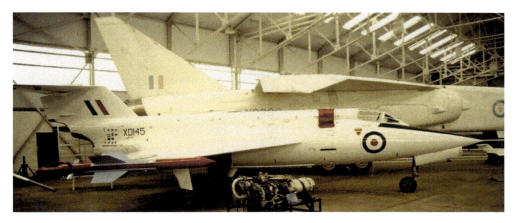

The SR.53 fighter jet. (Ministry of Defence)

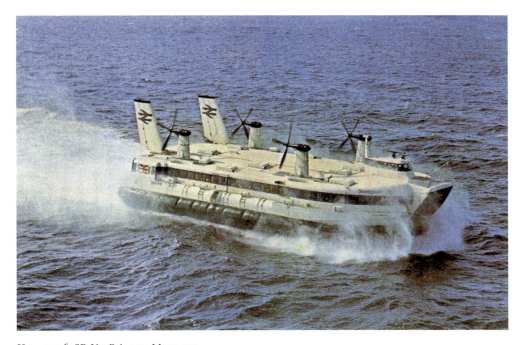

Hovercraft SR.N4 *Princess Margaret*.

Hovercraft

The Isle of Wight is the birthplace of the hovercraft and, once again, the company behind this achievement was Saunders-Roe, which later became the British Hovercraft Corporation.

The concept of the hovercraft, in which a cushion of air would lift the craft and enable it to skim across water, was invented and patented by Sir Christopher Cockerell, an engineer from Cambridge. Cockerell experimented with a vacuum cleaner and two tin

cans, but struggled to prove that his concept was viable. The aircraft and shipbuilding companies he approached saw that the idea had potential, but declined to develop it because it was outside their core business. In desperation, Sir Christopher approached the government-funded National Research Development Corporation, which in turn approached Saunders-Roe.

There were huge technical challenges to be overcome in turning Cockerell's theory into a practical working craft. Key was the problem of keeping a sufficient cushion of air beneath the vessel. The solution, developed by Saunders-Roe, was to fit a rubber 'curtain' around the perimeter of the craft. In 1959 the world's first hovercraft, the SR.N1, was born. This prototype could carry just four people, at a speed of 28 mph, but improvements came rapidly. In 1961 the SR.N2, the first commercial hovercraft, was carrying forty-eight paying passengers. In 1964, plans were developed for a much larger version. Four years later, the SR.N4 – dubbed the Concord of the Seas – was carrying 254 passengers and thirty cars across the English Channel to France at a speed of 83 knots (95 mph) and, in 1973, 418 passengers and sixty cars.

> DID YOU KNOW?
> Saunders-Roe manufactured secret military products during both world wars, including a Second World War motorised submersible canoe, or one-man submarine, nicknamed 'Sleeping Beauty'. Fifteen were built for use on undersea espionage missions such as attaching limpet mines to the hulls of enemy ships.

Sadly, this was to prove the high point for commercial hovercraft services. The soaring price of fuel and, later, the opening of the Channel Tunnel made these large craft uneconomic. This Isle of Wight invention, once seen as a symbol of national innovation and the future of transport proved to have more limited appeal in the long term. Christopher Cockerill's vision of a future in which huge, nuclear-powered hovercraft would fly across the Atlantic would never come to pass.

Water Speed Records

The Isle of Wight's connection to record-breaking powerboats stretches back to 1906, when the Yarrow-Napier, built by Samuel Saunders's boatyard for Lord Montague, won the Harmsworth Trophy at a then impressive 15.48 mph.

In 1937, Sir Malcolm Campbell turned to the company, by then known as Saunders-Roe, for a boat to win the world water speed record. The yard's Fred Cooper, son of a Newport stonemason and a hull designer of unparalleled ability, came up with Blue Bird K3. Cooper developed a hydroplane design, in which the boat was lifted largely out of the water at speed, the hull 'planing' along the surface. At the time, Blue Bird K3 was the most sophisticated craft of its type in the world.

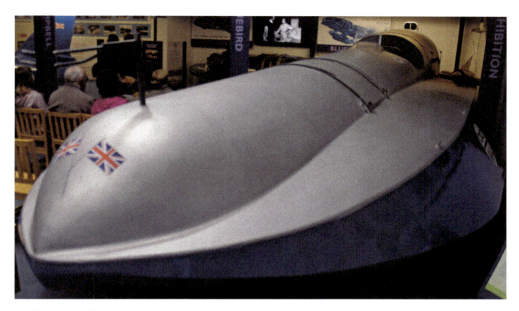

Bluebird K4. (Thomas's pics via Creative Commons)

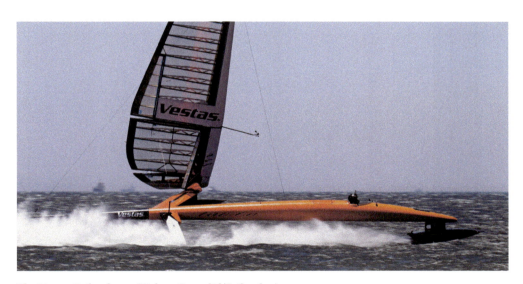

The Vestas Sailrocket 2. (Helena Darvelid/Sailrocket)

Campbell set the world water speed record three times in K3, culminating at 130.9 mph in 1938. Fred Cooper was involved in preliminary design work for Campbell's next boat, Blue Bird K4, but which was built by Vospers on the mainland, and which set the record again at 141.74 mph on Coniston Water in 1939.

In 1986 Sir Richard Branson broke the record for a craft crossing the Atlantic in a boat designed on the Isle of Wight. Branson made the crossing in three days, 8.5 hours at an

average 42 mph. His boat, Virgin Atlantic Challenger II, was designed by island-based Renato 'Sonny' Levi, who had been creating record-breaking boats since the sixties.

The most recent Isle of Wight record-breaker is the futuristic Vestas Sailrocket 2, built in the research facility of Vestas, a Danish wind turbine manufacturer, at the Medina Shop, Cowes, and launched in the Medina River in March 2011. It took the world sailing speed record over 500m the following year, when it reached the phenomenal speed for a sail-driven craft of 75.3mph. The craft's predecessor, Sailrocket 1, is on display at the Vestas Stag Lane research and development facility near Newport.

Land Speed Records

The Isle of Wight is also home to the remarkable Thrust 2, a car powered by a jet engine that held the world land speed record from 1983 to 1997. Thrust 2 was designed by John Ackroyd, whose first job was as an apprentice at Saunders-Roe, and who answered a newspaper advertisement that read: 'Wanted – 650 mph Car Designer'. The ad had been placed by Richard Noble, an ex-RAF pilot with the ambition to become the fastest man on earth.

The car took eight years to develop, and work took place at the Ranelagh Works in Fishbourne. Every item on Thrust 2, right down to the smallest nut and bolt, had to be specially engineered to aircraft standards, and many island companies played important roles in the project.

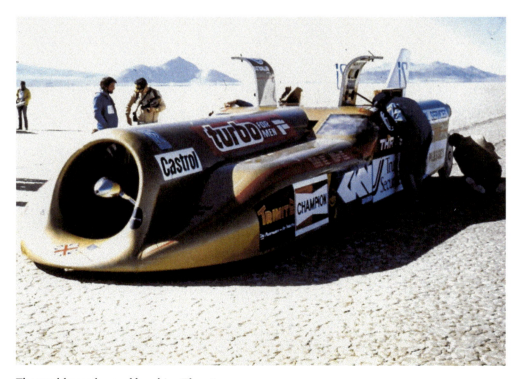

The world speed record-breaking Thrust 2.

In 1981 Noble took the UK land speed record at Greenham Common, reaching 248 mph. The following year he achieved 400 mph at Bonneville Salt Flats, Utah, USA, and then, in 1983, won the world record, with an average speed of 633 mph in Nevada's Black Rock Desert.

In 1997 Noble went one further: he built the world's first supersonic car, Thrust SSC. Driven by RAF fighter pilot Andy Green, it broke the sound barrier and set the first supersonic land speed record of 763 mph.

Record Attempt Balloon Capsules

Another of John Ackroyd's achievements was to design capsules for record-breaking high-altitude balloon expeditions. Once again he answered a newspaper advertisement, this time for a pressure capsule designer for the Endeavour balloon attempt, in 1985. The capsule was made at Island Plastics of East Cowes. That project failed, but Ackroyd went on to design the capsules for a series of record breaking attempts: Virgin Atlantic Flyer, which extended the distance record from 900 to 3,075 miles in 1987; Virgin Statoquest, which broke the altitude record at 64,997 feet (11 miles) in 1988; Pacific Flyer, which stretched the distance record to 6,700 miles in 1991; and Virgin Global Challenger, which sadly failed to complete a round-the-world flight in 1998. Not all John Ackroyd's capsules were built on the island, but all were designed here.

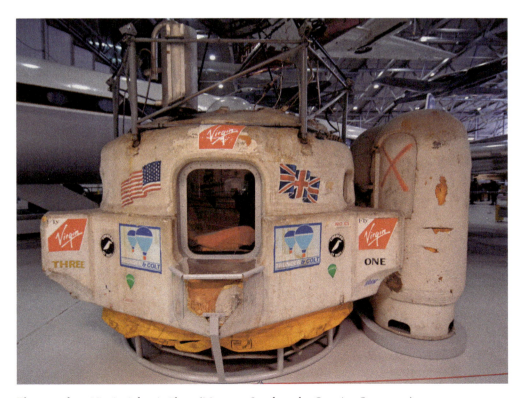

The capsule to Virgin Atlantic Flyer. (MoorwaySouth under Creative Commons)

Electric Cars

Before he got into fast cars and high-altitude balloons, John Ackroyd pioneered a far less glamourous but equally ground-breaking project: the design of the world's first production electric car. From 1971 to 1973 he designed the Enfield 8000 for Enfield Automotive at the company's Somerton Works, Northwood, Cowes.

The company, backed by Greek shipping magnate Giannis Goulandris, had won a competition run by the United Kingdom Electricity Council to design and build an electric car, beating major companies including Ford. At just 9 feet 3 inches long, the Enfield was 7 inches shorter than the original Mini, but at £2,600 it was twice the price. It had a top speed of 40 mph and a range of 55 miles, seated two and took 15.7 seconds to reach 30 mph.

The Enfield 8000 was designed as a city car and there were two variants: the Enfield Miner, a utility vehicle designed for the mining industry, and the Enfield Bikini, a leisure runabout.

The basic vehicles were assembled on the Greek island of Syros, and then shipped to the Isle of Wight for completion, but a wage dispute and strike disrupted production. Two hundred and twenty cars were built before production ended in 1976.

In 2015 motoring journalist Johnny Smith converted an original Enfield into a record breaker. His car, renamed the Flux Capacitor, broke the European speed record for a battery-operated vehicle when it travelled at 118.38 mph at the Santa Pod racetrack in Wellingborough, Northamptonshire.

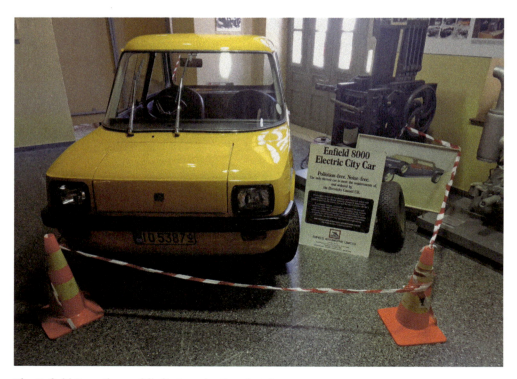

The Enfield 8000, the world's first production electric car.

The Largest Plane Ever Conceived

Not all Saunders-Roe's brilliant ideas were put into production. One of the most ambitious was a jet-propelled seaplane, which would have flown 1,000 passengers in ocean-liner comfort from London to Sydney.

In 1955 the company was approached by P&O (the Pacific and Orient Line) to design a giant sea-plane that would fly to Australia in forty-eight hours, a fraction of the six weeks it took by ship. Saunders-Roe carried out a feasibility study and developed initial designs for a plane, powered by twenty-four Rolls-Royce jet engines, and dubbed Queen. The fusilage was divided into five decks, with passengers sitting in groups of six in railway-like compartments where the seats could be converted into beds. In first class there would have been restaurants, bars and bathrooms. There would be forty cabin crew and seven pilots.

Not only would Queen have dwarfed anything then in the skies, but it remains today the largest airliner ever conceived. Unfortunately, neither P&O nor Saunders-Roe were prepared to invest the sum required to build a prototype.

> DID YOU KNOW?
> Among the most successful Isle of Wight powerboat racers was Marion 'Joe' Carstairs, dubbed the fastest woman on water in the 1920s. Joe, an heiress worth millions, was an unconventional figure who had relationships with the movie stars Marlene Dietrich, Tallulah Bankhead, and Greta Garbo. She commissioned powerboats from the premier boatbuilder Samuel Saunders.

Even more ambitious was the idea of building a nuclear-powered sea-plane, conceived by Saunders-Roe designer Henry Knowler, with a bank of engines on a huge tailplane. Such a concept seems outlandish today, and the risk of nuclear contamination in an accident too horrible to contemplate, but at the time atomic power was thought to have a major role in transport.

3. Rocking the Island

Even if it had come from a big-time rock and roll promoter with an established track record in promoting world-class events it would still have been an audacious request. Coming from the twenty-three-year-old proprietor of a small printing business in Totland Bay, it sounded impossibly ambitious. The request was: would Bob Dylan like to play a festival on the Isle of Wight in the summer of 1969?

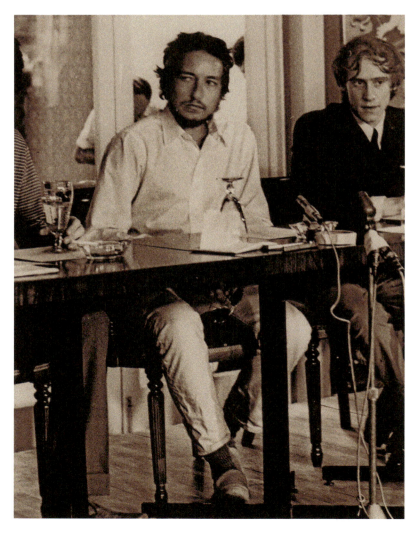

Bob Dylan with
Ray Foulk.
(Alamy)

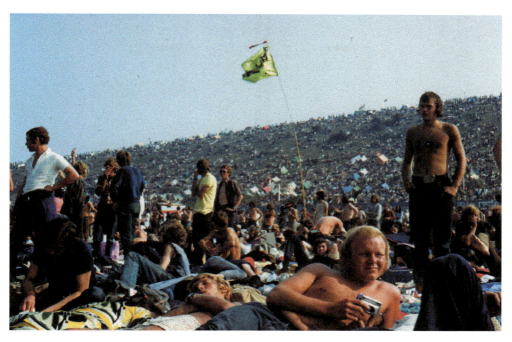

The 1970 festival crowd. (Roland Godefroy under Creative Commons)

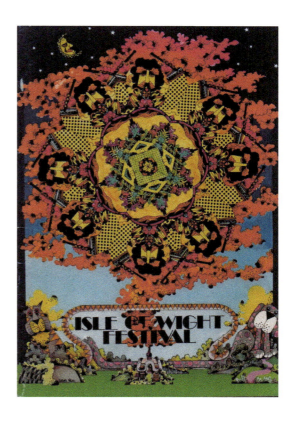

A 1970 souvenir programme.

Ray Foulk's past experience of running live music events was restricted to promoting a few concerts, and a one-night mini festival in 1968. Even acknowledging his achievement in booking the San Francisco psychedelic rock band Jefferson Airplane for that show, what on earth led him to believe that he could now bag one of the biggest stars in the world? After all, Dylan had not performed in public in the three years since he played the Royal Albert Hall on 27 May 1966, shortly after which he broke his neck in a motorbike accident.

On top of all that, Ray's festival would take place a few days after the mammoth one that was being held at Woodstock, close to Dylan's remote forest hideaway, and located there with the intention of winkling him out. Woodstock promised to be the greatest, most star-studded rock and roll event the world had ever seen. Would Bob Dylan really turn his back on all that to play a little island off the south coast of England? Surely not.

Yet, when the request was made to Dylan's management, Ray and his brothers Ron and Bill were not dismissed out of hand. In fact they had unwittingly offered Dylan an escape from a situation he dreaded. He felt Woodstock's organisers were trying to force him to come out to play, and he didn't like that. Also, playing the Isle of Wight, where he would be the undisputed star, allowed him to create his own festival, side-stepping the pressure of performing alongside the likes of Crosby Stills Nash and Young, Santana, Richie Havens, Janis Joplin and the Grateful Dead.

After the Isle of Wight, Dylan was to give no full concert performance until January 1974, four and a half years later, meaning his island appearance was his sole gig from the Summer of Love right through to the rise of Punk.

In the event, 200,000 came to see him, and the following year the Foulk brothers aimed even higher, putting on a show attended by at least 600,000 – 100,000 more than the attendance at Woodstock – and the largest festival of the time.

This trajectory was quite something: in two years the Foulks went from what Ray describes in his book *Stealing Dylan from Woodstock* as 'a small all-night festival in Hell Field [on Ford Farm near Godshill], in 1968 – originally devised in aid of a local swimming pool charity – to the world's largest gathering of the counterculture at the foot of Afton Downs in 1970'.

The 1969 Isle of Wight Festival

It was only on 16 July, just forty-five days before the show, that Ray got a telegram confirming: 'Dylan and Band will accept IOW Aug 31'. It meant a scramble to have the 41-acre site, a natural amphitheatre at Wootton Manor Farm, Woodside Bay, ready for the event. There was a vast cast to organise, including The Who, The Nice, the Moody Blues and Joe Cocker. The Foulk brothers organised all this from their former bedrooms on the top floor of the family home, Tavistock House in Totland Bay.

They rented a pleasant home for Dylan at Foreland Farm, Bembridge. It had a swimming pool, tennis court, and a stone barn in which Dylan and the Band rehearsed. Dylan was chauffeured around the island in a Humber Super Snipe, says Foulk, driven by a non-Dylan fan who commented, when the star came on the radio: 'Christ Almighty, whose is that voice?'

DID YOU KNOW?
Edwin A'Court Smith, a merchant seaman who retired to a cottage at Gurnard near Cowes in 1859, carried out extensive excavations on the Solent foreshore, and discovered a unique insect bed containing thousands of fossilised butterflies, flies, gnats, their larva and pupa.

Thomas Hawkins, an equally distinguished Wight fossil hunter, gathered a collection of fossilised sea creatures – *Ichthyosauri* and *Plesiosuari* – on the coast around Niton and Ventnor, which went to the National History Museum. He wrote of his finds in volumes including *The Book of the Great Sea Dragons*.

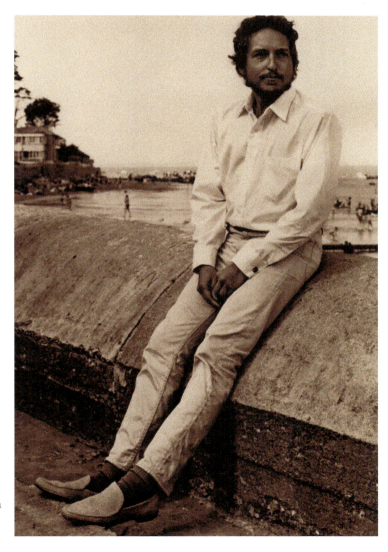

Bob Dylan, pictured on the prom at Seaview. (Alamy)

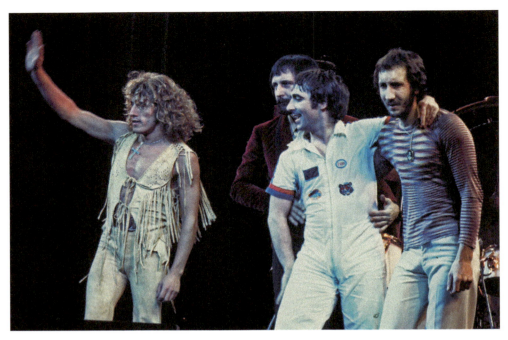
Dylan was supported by The Who. (Jim Summaria under Creative Commons)

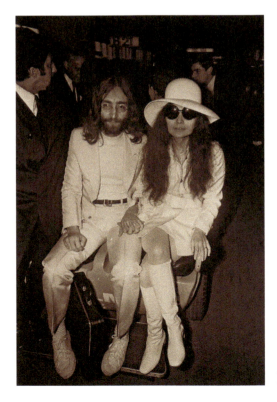
John Lennon and Yoko Ono were in the crowd. (Joost Evers under Creative Commons)

Press and fans mobbed the gates of the farm hoping for a glimpse of Dylan, so much so that a press conference was arranged at the since demolished Halland Hotel, Seaview, followed by a photo session on the promenade, when a relaxed Dylan posed on the sea wall.

When Dylan was asked why he had come to the Isle of Wight he replied: 'I wanted to see the home of Alfred, Lord Tennyson.' The interest was genuine. Dylan was familiar with Tennyson's work, and echoes of his poetry have been identified in Dylan's lyrics. At the time Tennyson's former home, Farringford House at Freshwater, was run as a hotel by Fred Pontin, owner of Pontin's holiday camps. Pontin refused to let Dylan visit, only to change his mind later when he saw the massive publicity the festival was drawing, but by then Bob had left the island. Bob did, however, get to see Osborne House, former home of Queen Victoria.

Dylan was as big a draw for other musicians as he was for press and fans. Three of the Beatles, John Lennon, George Harrison and Ringo Starr, visited him at Foreland Farm, Paul McCartney only staying away because his wife Linda had given birth to daughter Mary on 28 August.

Harrison, who came with his wife, Pattie Boyd, brought with him an acetate of the forthcoming Beatles album *Abbey Road*, which had only been finalised the day before. He and Dylan spent hours playing acoustic guitars and singing close harmony together on songs such as The Everly Brothers' 'All I Have To Do Is Dream'. It was a partnership they would rekindle when both joined the band The Traveling Wilburys along with Jeff Lynne, Roy Orbison and Tom Petty in 1988.

John Lennon came with Yoko Ono, his helicopter landing on the lawn, the downdraft turning the flowers in the carefully cultivated garden into, says Foulk, 'a confetti of decimated petals and leaves'.

When it came to delivering Dylan to the festival, Ray Foulk drove him in a battered old white Ford Transit van, Bob and his wife Sara sitting in the front passenger seats. In the back, on an improvised and unsecured bench seat taken from a Ford Zodiac, sat John, Yoko, Ringo and his wife Maureen. Disaster almost struck when Ray had to brake suddenly, then lurched forward, at a junction. As he writes in *Stealing Dylan from Woodstock*:

> [I heard] a resounding bang and crash along with screaming and shouting. The Zodiac seat had tipped back and there was John Lennon and the rest of the Beatles party stranded literally like beetles on their backs, legs flailing around ... everyone found this hilarious, including Bob.

Four songs recorded at the festival appeared on Dylan's 1970 album *Self Portrait*: 'She Belongs to Me', 'Like a Rolling Stone', 'The Mighty Quinn (Quinn the Eskimo)' and 'Minstrel Boy'. The whole seventeen-song set later appeared on a bonus CD with the luxury version of 2013's *Another Self-Portrait: Bootleg Series Volume 10*.

The 1970 Festival

Buoyed up with their success, the brothers planned something even bigger and better for 1970, but were forced into a cat-and-mouse game as protesting locals and authorities sought to prevent another festival being held, and they struggled to find a venue. Finally, they secured

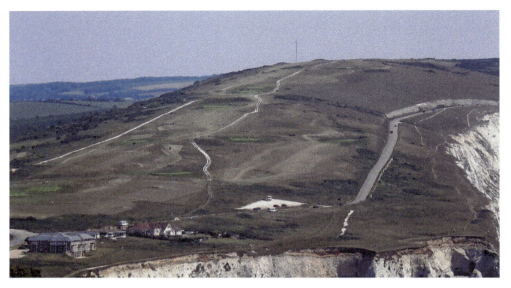

Afton Down overlooked the 1970 festival site. (Editor5708 under Creative Commons)

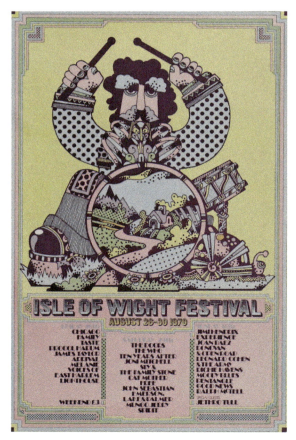

A poster for the Isle of Wight Festival 1970.

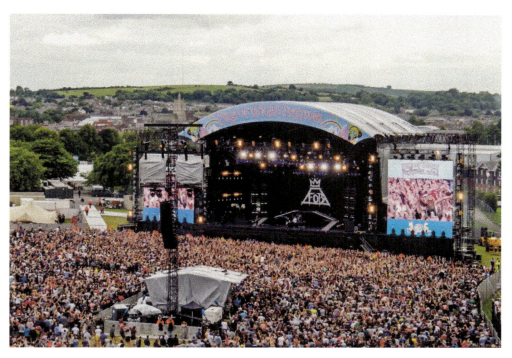

The revived 2014 festival. (Liz Murray under Creative Commons)

East Afton Farm, alongside Afton Down near Freshwater. One key drawback of the site was that Afton Down offered an elevated viewing platform from which many chose to watch the show for free.

At least 600,000 people was drawn to the show on an island with a population of less than 100,000. Despite being far better organised than the previous year, and pulling together a remarkable cast including Jimi Hendrix, Joni Mitchell, The Doors, The Who and Leonard Cohen, it came close to disaster. On the final day, with the fences torn down by anarchists, they were forced to declare the festival a free event. They struggled to get the money owed to them from ticket sales and catering, which they needed to pay their creditors, which led to the financial demise of their company, Fiery Creations.

The island's MP, Mark Woodnutt, succeeded in pushing a private member's bill – The Isle of Wight Act, 1971 – through the Commons. It outlawed gatherings of more than 5,000 between midnight and 6 a.m., effectively making future festivals unviable.

50th Anniversary Million Dollar Bash

It was not until 2002, thirty-two years later, that another festival was held on the island, organised by the Isle of Wight Council without the involvement of the Foulk brothers. The revived festival, held at Seaclose Park on the outskirts of Newport, became an annual event, with performers including The Rolling Stones, The Who, David Bowie, Bruce Springsteen, and Paul McCartney.

> **DID YOU KNOW?**
> Canned beer was invented on the Isle of Wight, by the Newport brewery Mew-Langton, as a revolutionary way to ensure their ales did not go flat by the time they reached troops in India and elsewhere. The brewers needed to add carbon dioxide to their beer to keep it fresh, but glass bottles proved too fragile for such a long journey. The solution, hit upon at the end of the nineteenth century, was to put their Crocker Street-brewed India Pale Ale in cans with a screw top.

In 2019, to mark the 50th anniversary of Dylan's appearance, a special anniversary festival called the Million Dollar Bash was held at the Isle of Wight County Showground, near Cowes. Dylan, who clearly held great affection for the original event, donated a previously unseen poem to be read out at the Bash. The poem, entitled 'Echo of the North Country', was about Echo Casey, Dylan's second girlfriend in his home town of Hibbing, Minnesota, who was the inspiration for his 1963 song 'Girl From The North Country', a track on his album *The Freewheelin' Bob Dylan*. She had died the previous year, aged seventy-five.

A Ticket to Ryde and a Ticket to Ride

The Beatles song 'A Ticket to Ride' was inspired, according to Paul McCartney, by a trip to Ryde to visit his cousin Margaret Robbins and her husband Mike, who ran a pub called The Bow Bars, now Bar 74, in Union Street, Ryde.

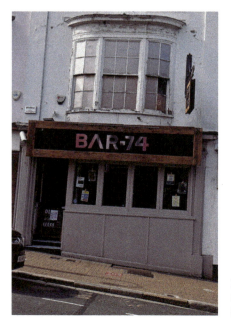

Bar 74, where John Lennon and Paul McCartney stayed when it was the Bow Bells. (Eric Koch under Creative Commons)

Lennon and McCartney.

Paul came with John Lennon in August 1960, taking advantage of a break between their last UK gig, in Wallasey on 30 July, and their next in Hamburg on 17 August. They hitch-hiked to Portsmouth and then bought a ticket on the ferry to Ryde.

The song was released as a single in April 1965 – becoming The Beatles' seventh No 1 – and was included on the album *Help!* The punning switch from Ryde to Ride is typical of Lennon and McCartney's way with words.

According to the Beatles Bible website Lennon claimed it as mainly his work, but Paul says:

> I remember talking about Ryde ... we wrote the melody together; you can hear on the record, John's taking the melody and I'm singing harmony with it. We'd often work those out as we wrote them. Because John sang it, you might have to give him 60 per cent of it...
>
> John just didn't take the time to explain that we sat down together and worked on that song for a full three-hour song-writing session, and at the end of it all we had all the words, we had the harmonies, and we had all the little bits.

Bar 74 has a long history. It opened as The Havannah in the 1870s. From 1875 to 1956 it was called The Bodega Wine Stores, then The Bow Bars, The Liquid Lounge and now Bar 74. Paul's younger brother Mike worked the following summer at The Bow Bars as a short-order cook.

The song 'When I'm 64', on the album *Sgt Pepper's Lonely Hearts Club Band,* also refers to the Isle of Wight, this time as the perfect place to rent a holiday cottage, 'if it's not too dear'.

DID YOU KNOW?

Jimi Hendrix's appearance at the Isle of Wight Festival is remembered in two works of art on the island. One is a Hendrix statue in the gardens of Dimbola, the former Freshwater home of the photographer Julia Margaret Cameron. The other is a mural on the walls of the Nightingale Hotel, Queen's Road, Shanklin, which features Hendrix alongside another performer at the 1970 event, Jim Morrison of The Doors.

Above left: Jimi Hendrix statue at Dimbola, Freshwater.

Above right: Hendrix mural at the Nightingale Hotel, Shanklin.

4. Three Remarkable Scientists

Three remarkable scientists have achieved world firsts on the Isle of Wight. One, Guglielmo Marconi, ushered in the modern age of instant global communication when he established the world's first permanent wireless radio station here. The second, John Milne, made the island the foremost centre for Earthquake Science. The third, Robert Hooke, was dubbed England's Leonardo for the remarkable breadth and brilliance of his inventions and discoveries, covering fields as diverse as light waves, micro-organisms, gravity, and map-making.

Marconi, and the Birth of Radio

The twenty-three-year-old Italian, who checked in to the Royal Needles Hotel at Alum Bay in November 1897 had a decidedly unusual request: could he erect a 168-feet-high mast in the grounds of the hotel?

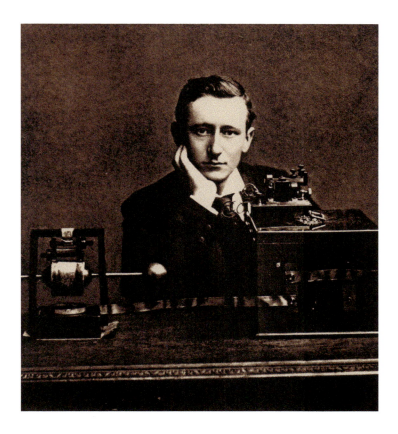

Guglielmo Marconi.

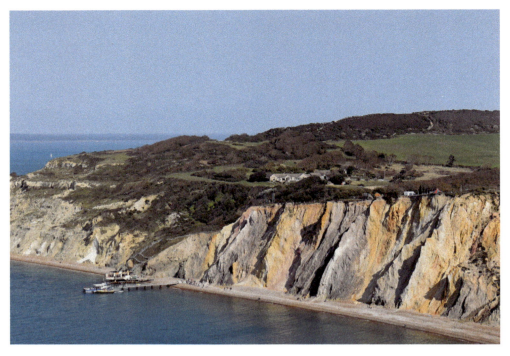

Alum Bay.

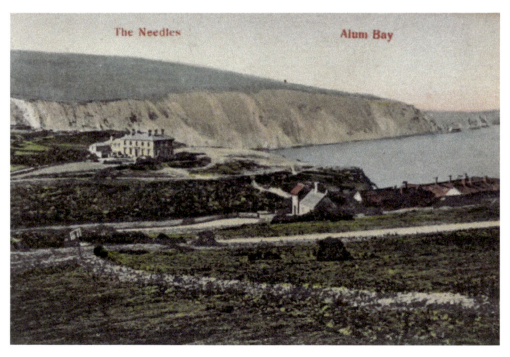

Marconi invented radio at the Royal Needles Hotel, shown in this old postcard, above Alum Bay.

The young man was Guglielmo Marconi and, it being low season and guests scarce, his request was granted. Today, there are few physical reminders of the fact that, on the island, Marconi developed the technology that underpins modern life, paving the way for radio, television, telephones, mobile phones, Wi-Fi and broadband. Prior to his invention, electronic communications could only be sent as telegrams, along telegraph wires.

The Royal Needles Hotel burned down in 1910, the land on which it stood later sliding into the sea. Just a memorial plaque, and a café called Marconi's Licensed Tearooms, stand as reminders of the fact that the world's first permanent wireless radio station stood here.

Marconi saw the first practical application for his invention as communication with ships at sea, which, previously, were out of contact as soon as they dipped below the horizon. To conduct his experiments, he needed an elevated coastal site, remote enough to avoid electrical interference, and that huge mast which, as John Medland writes in *The Isle of Wight and the Birth of Radio*, had to be hauled up the face of Alum Bay from the ship that delivered it by all the able-bodied men of the nearby village of Totland.

Marconi converted the hotel's billiard room into a radio station from which he sought to communicate with ships he hired, fitted with aerials and receivers, and that plied back and forth along the Solent. Totland's sub-postmaster, Joseph Garlick, was asked to test the equipment in the billiard room. John Medland writes:

> Asked to send a message, he tapped the world 'Marconi' into the transmitter. To his surprise a moving bar at the end of the table, not visibly connected, repeated the word. 'He picked up the letters on his instrument and was obviously delighted that I had chosen to send his name'.

Despite atrocious winter weather, further experiments proved that radio signals could be successfully transmitted from ship to shore.

How Radio Let Queen Victoria Keep Tabs on Her Playboy Son

In August 1898, Marconi enabled Queen Victoria to communicate electronically from her island home, Osborne House, with her wayward son Albert, Prince of Wales, who thought he could avoid his mother by hiding out on the Solent in the royal yacht.

As Marconi's daughter Degna remembers in *My Father, Marconi*, the fifty-seven-year-old playboy prince, the future Edward VII, had gone to a ball at the Rothchild palace in Paris and fallen downstairs, twisting his knee. He did not want to convalesce in Osborne House, with Victoria fussing over him, and believed that on the yacht there would be 'an unbridgeable gulf between himself and his solicitous mother'.

He was wrong. Marconi placed an 83-feet mast on the ship and a 100-feet one at Osborne House, making communication possible. Over sixteen days, 150 messages were exchanged, Victoria's often 150 words long, the prince's far shorter, often restricted to: 'The Prince of Wales has passed a most excellent night' and 'the knee is most satisfactory'.

The cafe named after Marconi at the Needles.

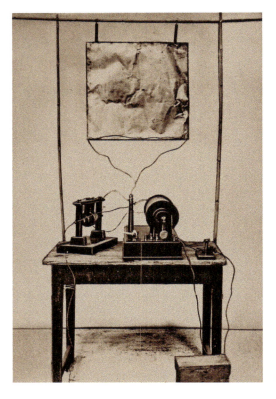

Marconi's first radio transmitter.

The plaque recording Marconi's achievement. (Pixabay)

The following year, when Marconi was travelling back from America on the SS *St Paul*, he received enough information from his Needles station to publish *The Transatlantic Times*, the first newspaper printed at sea.

DID YOU KNOW?
A trickle of brown water that flows into the gutter along the road leading from the Esplanade to the cliff-face lift is a reminder of Shanklin's lost spa. The source, flowing from the foot of the cliffs, is said to have been discovered by Charles II's doctor. In the nineteenth century the Esplanade Spa Hotel, later renamed the Royal Spa Hotel, exploited the iron-rich waters. In 1900, elegant bath houses were built alongside the hotel, which was bombed to destruction in the Second World War. Today only the vaults remain.

Despite these achievements, Marconi's invention was not an instant commercial success and, in 1900, he almost went bankrupt when William Berkeley, owner of the Royal Needles Hotel, demanded an extra £1 a week in rent. Unable to pay, Marconi packed up

his equipment and took it 15 miles to Knowles Farm, Niton, on the island's southern shore, where he established a new radio station, and took rooms at the Royal Sandrock Hotel. Like the Royal Needles, this hotel also burnt down, in 1984. It was from Niton that Marconi proved radio waves would follow the curvature of the earth, and that the first trans-Atlantic communication was achieved. The age of radio had arrived. In ten years there would be over 500 radio stations, enabling worldwide radio communication, with the first voice transmission achieved in 1906.

The Death of the Bees

In 1904 the bees on the Isle of Wight began to die of a mysterious disease. Around 90 per cent of the island's honey bees were wiped out, and what became known as Isle of Wight Disease spread to the mainland with similarly catastrophic results. Native bee varieties were virtually annihilated.

What could be the cause? A rumour spread that what Marconi was doing with radio waves held the answer. At the time of the outbreak there were four radio stations on the island, and it was the most irradiated area in the world.

Brother Adam, who bred the disease-resistant Buckfast bee. (Humboldt55 under Creative Commons)

A bee from the disease-immune strain bred by Brother Adam.

Opinion is still divided on whether radio waves can be harmful, but at the time there was a fear that they could have a profound impact on human health. Some believed that the intense fevers Marconi suffered while setting up a transmitter powerful enough for transatlantic communications were caused by the high intensity radio waves that he encountered. There was even a belief in some quarters that the cerebral haemorrhages that killed Queen Victoria on 22 January 1901 were caused by the transmitter Marconi was then switching on just over 12 miles away from Osborne House at Knowles Farm.

Fortunately, the bees had a saviour. He was Brother Adam, a Benedictine monk, expert bee-keeper and breeder at Buckfast Abbey in Devon. Brother Adam travelled to Turkey to find substitutes for Britain's native bees, and bred the Buckfast bee, a very productive strain that was resistant to Isle of Wight Disease.

It took some time for scientists to identify the true cause of Isle of Wight Disease. In 1921 John Rennie, an expert in parasitology, concluded it was caused by *Acarapis woodi*, a parasitic mite that attacked the bees' breathing tubes, but this later proved not to be the whole answer. It was not until the 1980s that Larissa Bailey and B. Ball established that, while *Acarapis woodi* mites were a contributing factor in the deaths, a more fundamental cause was Chronic Bee Paralysis Virus.

John Milne, Pioneer of Earthquake Science

Few in Britain have heard of John Milne, but in Japan he is revered as the father of earthquake science, and was awarded that country's highest honour, the Order of the Rising Sun. Very few people – even on the Isle of Wight – know that, for almost two

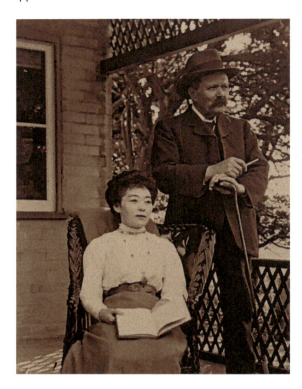

John Milne and his Japanese wife Toné.

The former gatehouse to Shide House.

The former servants' quarters at Shide House.

decades at the turn of the century, Milne's observatory at Newport was the world centre for seismology.

In 1880 Milne, a British geologist and mining engineer, was working in Japan when a very large earthquake struck Yokohama. At the time it was not possible to detect and measure the strength of earthquakes, or to predict when they were likely to occur. Milne, together with British colleagues Sir James Ewing and Thomas Gray, founded the Seismological Society of Japan to try to do exactly that.

The society funded the development of measuring equipment, and Milne invented the horizontal pendulum seismograph, which enabled him to measure the velocity of earthquake waves, and to detect different types of wave. The society trained many Japanese students in seismology, one of whom – Seikei Sekiya – went on to become the world's first professor of seismology, at Tokyo's Imperial University.

Milne married Toné Horikawa, the daughter of a Buddhist monk, but in 1895 disaster struck when fire destroyed his house, library and observatory, and most of his instruments.

Milne resigned and moved with Toné to Shide Hill House at Shide, on the outskirts of Newport. Here he continued his seismographical studies, persuading the Royal Society to fund what became a series of forty earthquake observatories spanning the globe, all equipped with Milne's horizontal pendulum seismograph.

> **DID YOU KNOW?**
> The handsome art nouveau building that houses Jolliffe's café in Shooters Hill, Cowes, has retained its name from when this was the shoe shop of H. Jolliffe & Sons. The shop was opened in 1853 by Henry Jolliffe and was in the family for three generations until 1991 when Gladys Jolliffe, Henry's granddaughter, retired. The original shop burned down on New Year's Eve 1915 and was replaced with the present, listed building, designed by another Jolliffe, the architect Reginald. Jolliffe's supplied boots and shoes for royal staff at Osborne House while Queen Victoria was living there.

The observatories sent data back to Milne's observatory at Shide Hill House, which, for the next twenty years, was the world centre for earthquake research. He wrote the standard textbook on earthquakes, and compiled an annual report, drawn from his analysis.

Milne died of kidney disease in 1913, and was buried in St Paul's Church, Newport. Shide Hill House, which stood between Blackwater Road and St George's Lane, was demolished in the 1970s. The only surviving parts of what was a substantial estate are the gatehouse, at the bottom of St George's Lane, the Laboratory Block, and the servants' quarters at No. 24 St George's Lane, now called Milne House. Milne's observatory, which was in the stable block, was dismantled and moved to the Oxford Observatory in 1919 when his widow returned to Japan.

Robert Hooke, England's Leonardo

Comparing anyone to Leonardo da Vinci, the Italian polymath of the high Renaissance, sounds like hyperbole. Who could possibly match a man famed for, among other things, painting the Mona Lisa and the Last Supper; a pioneering understanding of robotics, anatomy, solar power and plate tectonics; and sketching designs that prefigured inventions including the tank, parachute, glider and helicopter?

Yet Robert Hooke, born in Freshwater in 1635, son of the curate of All Saints' Church in the village, had a similarly wide-ranging list of achievements. Unfairly, the man who was the colleague and equal of both Isaac Newton and Christopher Wren, and played a huge part in their achievements, has nothing like their place in history.

Robert's genius became apparent when he enrolled at Westminster School, in London, where he quickly mastered ancient languages, learned to play the organ, and drew a prototype flying machine. Next, he won a poor scholar's place at Christ Church, Oxford, where Christopher Wren encouraged him in astronomy, mathematics and mechanics. From others he learned anatomy and dissection, and a mastery of chemistry and lab skills.

He joined the newly formed Royal Society but initially, as a man without the riches or title to match his brilliance, as a lowly employee rather than a fellow. At the age of just thirty he became professor of geometry at Gresham College, London, and the first salaried research scientist in Britain.

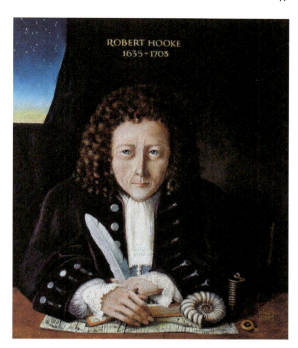

Robert Hooke, England's Leonardo.

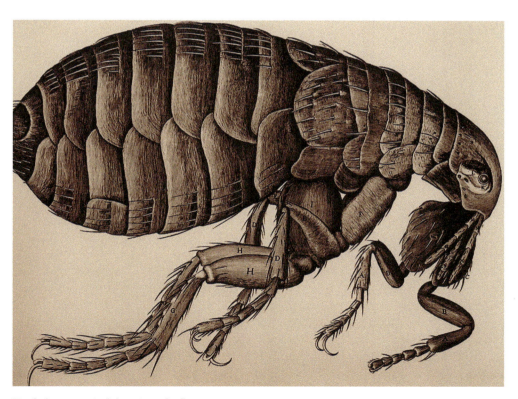

Hooke's anatomical drawing of a flea.

Stone from Hooke's demolished home, including one dated 1694, was used to build St Agnes's Church in Freshwater Bay.

His pioneering work in cartography enabled the development of modern two-dimensional mapping, and he achieved wealth and fame by supervising, together with Christopher Wren, the rebuilding of areas of the city destroyed in the Great Fire of London of 1666. He designed many buildings, including the monument to the fire, the Royal College of Physicians' headquarters in Warwick Lane, and Bethlem Hospital in Moorfields. However, the grid system he proposed for a reborn city was rejected in favour of following the existing road pattern.

Hooke built the first Gregorian Telescope, a type of reflecting telescope designed by Scottish mathematician and astronomer James Gregory, and was then able to study the rotations of the planets Mars and Jupiter.

He worked with microscopes, too, studying microscopic fossils and developing theories of biological evolution that anticipated Darwin's breakthrough work, *The Origin of Species*. He made highly detailed sketches of creatures he studied, including the flea. In

physics he conducted experiments into the laws of gravity that anticipated Isaac Newton's law of universal gravitation.

Hooke felt cheated when Newton presented this law to the Royal Society in 1686. He had been working on his own theory for twenty-five years, and had shared many of his ideas with Newton, but it was Newton who snatched the glory, and failed to acknowledge Hooke's contribution. Robert Hooke died, embittered, in 1703.

The Hooke name lives on in Freshwater in Hooke Hill. The family home was a house known as Hooke's Cottage or Hooke Hill Farm. The house was demolished in 1908 and the stone used to build St Agnes' Church in Freshwater Bay, where a stone set in the vestry wall bearing the date 1694 leads many visitors to believe the church is far older than it actually is.

DID YOU KNOW?
Sir Thomas Brisbane, after whom the Australian city is named, presented Ventnor with a groundbreaking scientific instrument in 1851. The Gnomon, a curiously shaped ball on a spike which stands on the Esplanade, is a sundial post that casts a shadow on a line on the pavement at exactly midday, GMT. Brisbane, a keen astronomer who was governor of New South Wales, lived in Ventnor for a time. His daughter, Eleanor Australia, died in in the town aged just twenty-nine in 1852. In the Queensland city named after him there is the Sir Thomas Brisbane Planetarium.

Sir Thomas Brisbane's Gnomon, Ventnor.

5. A Secret Royal Estate, and the Grave of a Forgotten Princess

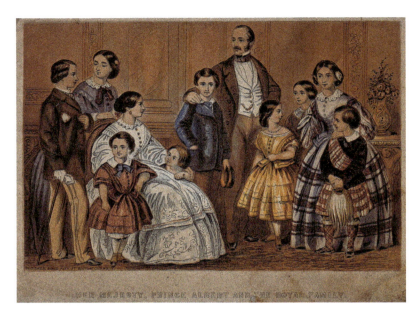

Queen Victoria with her family. (Wellcome Collection)

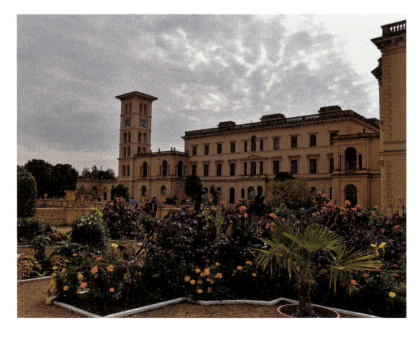

Victoria's public home, Osborne House.

Perhaps the two best-known royal facts about the Isle of Wight are that Queen Victoria made her home at Osborne House, and that Charles I was imprisoned in Carisbrooke Castle. What is far less well known is that Victoria also had a second, very private estate adjacent to Osborne, and that Charles I's daughter Elizabeth died on the island, aged just fourteen, and is buried in a grave that was forgotten for 143 years.

Barton Manor: Victoria's Other Island Estate

Not far from the well-signposted driveway that draws 350,000 visitors a year to Osborne House is another drive leading to a more modest country house. This driveway, just 700 metres further along the A3021 Whippingham Road, is much more discreet. You would need to look closely at the small, round monograms on the gates beside the lodge to spot the royal connection, but there it is: the entwined initials V and A, for Victoria and Albert.

This is the entrance to Barton Manor and, while Osborne was the Queen's official residence on the island from 1845, the adjoining estate of Barton Manor was bought in the same year as a much more private home for the royal family. It stayed in royal hands until 1922.

Both estates had initially been rented the previous year, for twelve months, while Victoria and Albert decided which best suited them.

In the event, the royal couple settled on Osborne as their official residence, but bought Barton Manor as a place where Albert could achieve his ambition to create a model farm, applying all the latest agricultural techniques, and where the couple and their children could retreat for a more normal family life.

Victoria and Albert's entwined initials. (John Armagh under Creative Commons)

The lodge at Barton Manor.

Not that Albert was content with the two houses as they stood. He designed a new Italianate villa to replace Osborne House and extensively remodelled Barton. An entry in Victoria's diary from March 1845 reveals just how important Barton Manor, and the privacy it afforded, was to her:

> Another fine day. Immediately after breakfast we took a delightful long walk by Barton Farm, the woodman's cottage, down through the woods, where the birds were singing, to the sea. We are so delighted with our purchase; the grounds are so extensive, and the woods would be lovely anywhere, but going down to the edge of the sea, as they do, makes it quite a paradise, added to which it is so private and we can walk about anywhere, unmolested.

Barton Manor did also serve a practical purpose, as a supplement to Osborne House. It provided additional accommodation for equerries, diplomats and visiting family, and it acted as the Home Farm to Osborne, supplying it with produce.

The Jacobean farmhouse the couple inherited was largely rebuilt. The exterior was carefully repaired with matching stone, and bricks fired in their own brickyard; the interior was gutted, old panelling removed, and a royal apartment established in the south-east wing. A suite of kitchens was added to supplement those at Osborne when banquets were being prepared.

In 1852, Albert designed a range of modern brick and stone farm buildings incorporating the latest agricultural innovations. His dairy was ultra clean, with tiled floors, stone shelves on which the milk was kept fresh, and an elaborate central fountain that cooled the air in summer. A steam engine pumped water to Osborne, to serve the house and power garden fountains, while a second turned a drive shaft that ran a mill, a threshing machine, corn elevators and other innovative machinery. He remodelled the grounds too, planting many trees to enhance the views, and a large Cork Oak plantation.

> DID YOU KNOW?
> When Napoleon III's army was defeated by the Germans in 1870 and he was taken prisoner, his wife, the Empress Eugenie, fled France for the Isle of Wight, home of her friend Queen Victoria, landing at Ryde Pier. Eugenie was so dishevelled from her flight that staff at the Royal Pier Hotel refused to believe she was the empress and sent her away. She stayed instead at the Royal York Hotel in George Street. In later years she visited Victoria each summer, staying at Osborne Cottage.

Albert's death in 1861 plunged Victoria into profound mourning that barely eased until her death in 1901, but Barton Manor remained a sanctuary for her, and she continued Albert's enhancements. In the year of his death, a large lake – Barton Pond – was dug on which there was skating in winter.

Edward VII Continues the Tradition

Edward had unhappy childhood memories of Osborne, and gave it to the nation soon after his mother's death, but he retained Barton Manor as his favourite summer retreat, continuing his father's work by building cottages in the grounds in the style of the farmhouse, landscaping terraces leading down to the lake, creating a walled garden and planting more trees.

Edward loved to entertain at Barton and, in 1909, Tsar Nicholas II of Russia and his family came here. Nicholas was married to Princess Alexandra of Hesse, one of Victoria's favourite granddaughters. She had spent holidays at Osborne as a girl and had brought Nicolas to visit before their marriage.

The Sale of Barton Manor

After Edward VII's death in 1910, his successor George V had little interest in Barton Manor, and in 1922 sold the estate to the Tillett family, who continued to use Albert's farm buildings and dairy.

Victoria's youngest daughter Beatrice, who became Governor of the Isle of Wight and lived in an apartment in Carisbrooke Castle until her death in 1944, retained an affection for Barton Manor and regularly visited the Tilletts. The ornate embossed iron gates with their V and A monograms only survive because of Mr Tillett's foresight. When, during the

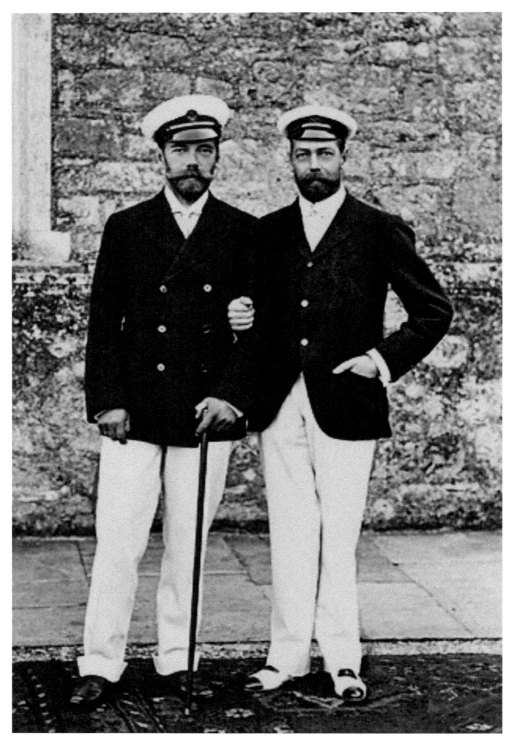
The Tsar and the Prince of Wales, future George V.

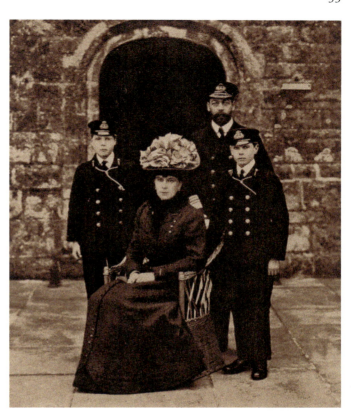

The Prince of Wales and family at Barton Manor.

Second World War, officials requisitioned them along with estate railings, he negotiated to give them Albert's boiler and engine from the manor's boiler room instead. In 1952 the Tillett family moved to Devon, and the estate was split into its constituent farms and sold at auction.

Madonna at Barton Manor
Barton Manor itself, with about 26 acres including the private beach, went through a number of owners until being bought, in 1976, by Anthony and Alix Goddard, who planted a vineyard and opened the grounds to the public. Barton Manor wines won gold medals in national competitions, and were served at Buckingham Palace and the Houses of Parliament. In 1987 the farm buildings adjoining the manor house came up for sale and the Goddards bought and restored them. This phase in the manor's life came to a premature end in 1991 when Goddard, a Lloyds name, was hit by the crash in the insurance market and had to sell. The couple went on to found Goddard's Brewery at Ryde.

Barton Manor was bought by the impresario Robert Stigwood, best known for managing Cream and the Bee Gees, theatre productions including *Hair* and *Jesus Christ Superstar*, and films such as *Saturday Night Fever* and *Grease*. Under him, Barton Manor became a private retreat once more, the vines grubbed out and the gates closed to the public, apart from four fundraising events each year for the Island Hospice.

The impresario Robert Stigwood.
(Allan Warren under Creative Commons)

Stigwood welcomed guests including
Madonna to Barton Manor. (chrisweger
under Creative Commons)

Stigwood was occasionally seen arriving from the mainland by helicopter, but was rarely spotted outside the gates. He entertained famous friends and favourite clients here, including Madonna, who was seen jogging along the front at East Cowes around the time Stigwood was producing the film of *Evita*, in which she starred. He sold up in 2006.

Barton Manor is now run as a wedding venue, holiday let and to host events. In 2018, on the centenary of the Romanov family's execution, an exhibition remembering their visit to the manor was held in the barn. At the same time a monument to the Romanovs was unveiled at Jubilee Park, East Cowes.

DID YOU KNOW?
The Donald McGill Postcard Museum is very appropriately placed on the Isle of Wight – in Royal Victoria Arcade, Union Street, Ryde – given that it was an island vicar's complaint about his saucy postcards that unleashed a nationwide vendetta against the cartoonist. McGill was found guilty of breaking the Obscene Publications Act, and his postcards seized and destroyed in a string of seaside towns – 5,000 of them in Ryde alone.

One of his drawings, featuring a bookish man asking a pretty woman 'Do you like Kipling?' and her responding 'I don't know, you naughty boy, I've never kippled!', sold a world-record 6 million copies.

Forgotten Grave of Tragic Princess Elizabeth

The story of the young Princess Elizabeth Stuart, daughter of Charles I, is a tragic one. Her father had been imprisoned at Carisbrooke Castle in 1647–48, prior to his execution in London in 1649. His son, who would become Charles II, had escaped to Scotland and been crowned king there. Because his other children were seen as a threat to Oliver Cromwell's Protectorate, Elizabeth and her brother Henry were kept captive, first in the relative comfort of Penshurst Place in Kent and then, in 1650, at Carisbrooke.

Charles Spencer, in *To Catch A King*, explains: 'having the royal children cooped up there stopped them from becoming figureheads for any who might be planning a Royalist uprising in mainland England.'

It was to prove a fatal move for Elisabeth, whose health was poor. She caught cold when soaked by a shower on the castle's bowling green, contracted pneumonia and died, within weeks of her arrival at Carisbrooke, aged just fourteen. Poignantly, as Charles Spencer writes:

> Two days later news reached the Isle of Wight that permission had finally been granted by Parliament for the princess and her younger brother to depart for the Netherlands, where they were to be handed over to the care of their older sister, Mary.

There would be no ceremonial royal funeral for Elizabeth. Instead, she was buried in the local Church of St Thomas, Newport, with just her servants and a few local officials in

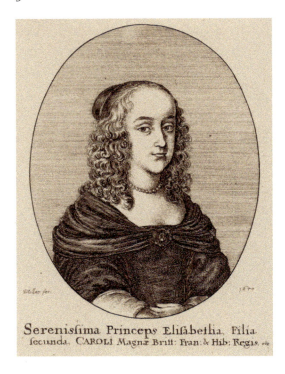

Princess Elizabeth, who died aged fourteen.

The princess was buried at St Thomas's, Newport Minster.

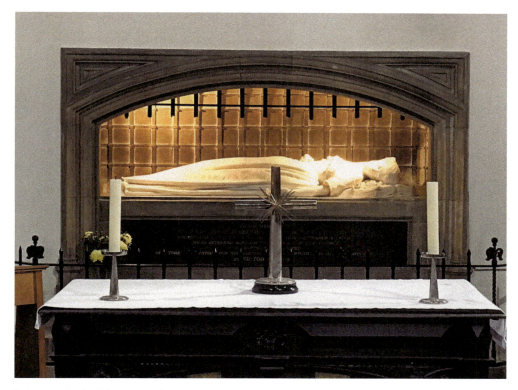

Princess Elizabeth's memorial in Newport Minster.

attendance. Her lead coffin was placed in an unmarked vault halfway down the east side of the chancel, in St Thomas's Chapel. There she remained for 143 years until, in 1793, part of the chancel floor was lifted during excavations for a new interment.

In his contemporary account of the discovery, Charles Tomkins, in *A Tour to the Isle of Wight*, wrote that her coffin: 'was discovered in a vault which was perfectly dry when it was opened, and the coffin in a state almost equal to new'. Tomkins went on:

> Upon the wall of the chancel not far distant from the vault, is a small stone, with the letters E. S. [for Elizabeth Stuart] cut in it. This obscure inscription had passed almost without notice, till the coffin was discovered, but it now seems clear, that it was meant as a direction to those who might search for the grave of this unfortunate young princess.

An inscription on a brass plate on the lid of the coffin identified this as 'Elizabeth, 2nd Daughter of ye Late King Charles. Decd Sept 8th, 1650'. The grave was closed up again, and a brass plate attached to now identify it as the resting place of a princess. However, to keep expense to a minimum, the brass plate was taken from another grave in the church, reversed, and reused.

When Queen Victoria came to Osborne and West Barton in 1854, and learned that a royal princess lay in such a humble grave, she determined to do something about it. She

had built a new, grander Church of St Thomas – which became Newport Minster in 2008 – for Elizabeth to rest in, and a favourite sculptor, Carlo Marochetti, was commissioned to create a fitting monument in Carrara marble. It depicts Elizabeth laying as she is reputed to have been discovered, with her head on the open Bible given to her by her father at their final meeting.

The girl who modelled for Marochetti was ten-year-old Julia Prinsep Jackson, who would later give birth to Virginia Woolf, the author.

At the same time, Elizabeth's remains were exhumed and medically examined by Ernest Wilkins, surgeon and curator of the Isle of Wight Museum. He concluded that the princess had suffered from advanced rickets, a softening and weakening of the bones found in children, usually caused by extreme and prolonged vitamin D deficiency. As Elizabeth had been a prisoner from the age of six, it is very likely that her incarceration killed her.

DID YOU KNOW?
Edward Lear, who gave Queen Victoria a series of twelve drawing lessons at Osborne House in 1846, also wrote a limerick during his time on the island:

> There was a Young Lady of Ryde,
> Whose shoe-strings were seldom untied.
> She purchased some clogs,
> And some small spotted dogs,
> And frequently walked about Ryde.

6. Appuldurcombe and the Worsleys

The story of Appuldurcombe House and the Worsley family that owned it for three centuries is, on one hand, a tale of huge wealth, close links with royalty, and great social standing. On the other, it is one of tragedy, scandal, disgrace and destruction.

James Worsley, Henry VIII's Favourite

James Worsley was already hugely powerful and well connected when he married Anne Leigh, heiress of Appuldurcombe House and extensive lands stretching across the island from Bembridge to Chale.

James had been page to Henry VII, and was brought up with the king's son who, when he became Henry VIII, knighted his childhood friend and appointed him Keeper of the Wardrobe. In 1511, further honours followed: Sir James was given a virtual monopoly of official posts on the Isle of Wight. He became captain of the island, responsible for its defence; sheriff; coroner; and constable of Carisbrooke Castle, the seat of power.

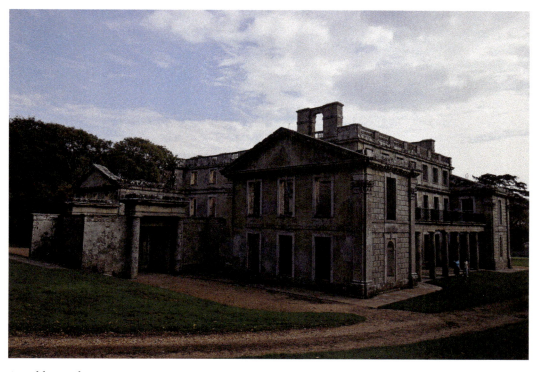

Appuldurcombe House.

Appuldurcombe's parkland, landscaped by Capability Brown.

James and Anne Worsley on their tomb at Godshill. (BritainExpress)

The Leighs had held Appuldurcombe on a lease from the order of nuns that owned it but, at the Reformation, Henry gave it to the Worsleys, further consolidating James's power on the island.

James was clearly very grateful for the king's largesse. When he died, in 1538, he left his finest gold chain to Henry VIII, and his largest goblet to Thomas Cromwell, the king's right-hand man. A Holbein portrait of Henry, said to have been given to James when he and Cromwell visited Appuldurcombe, remained in the house until 1855.

The Tragic Death of Two Young Boys

James's descendant, Sir Richard Worsley, took on his ancestor's roles, and distinguished himself in 1545 when he defeated invading French forces who were intent on burning Appuldurcombe and the neighbouring village of Wroxall in the Battle of Bonchurch. However, twenty-two years later, fears of a further invasion would bring tragedy to the Worsley family. There were rumours of enemy ships sighted in the channel, and forces were mustered at Appuldurcombe to repel them. As part of the preparations for battle, servants were drying gunpowder in the gatehouse, assisted by Sir Richard's two young sons, John and George, aged eight and nine. The inscription on the boys' tomb in All Saints, Godshill, recounts how:

> Beinge in ye lodge of Appuldurcombe the servants were dryinge of powder against ye general mowster, 1567, a sparkle flew into ye dische that sett fyre to a barrell that stood bye her, blew up a side of ye Gate House and killed ye two children, eight and nine years of adge.

Sir Richard had died two years before and his widow, Lady Ursula, had remarried. Her new husband was Sir Francis Walsingham, principal secretary to Elizabeth I, and Ursula was heavily pregnant at the time of the tragedy. Three weeks after the death of her sons she would give birth to Frances, the first of two daughters with Walsingham. Frances would go on to marry Sir Philip Sidney, courtier, poet, soldier, and one of the most prominent figures of the Elizabethan age.

The Scandalous Lady W

The best-known story of Appuldurcombe and the Worsleys is the scandal of a later Sir Richard and his wife Seymour. In 2015 the BBC made a film about the episode, *The Scandalous Lady W*, based upon Hallie Rubenhold's book *Lady Worsley's Whim*.

Worsley had married Seymour, a seventeen-year-old heiress, in 1775. She brought a dowry of £70,000, (£11.4 million today according to the Bank of England's Inflation Calculator), which was much needed by the profligate squire of Appuldurcombe. However, the marriage ended just seven years later in a court case that caused a sensation. Lady Worsley had run through twenty-seven lovers before Sir Richard unwisely sued one of them, George Bisset, for what was called criminal conversation: adultery.

The action was unwise because, as evidence produced in court revealed, Worsley was an obsessive voyeur who arranged for men to see his wife naked, and who spied on her while she had sex with her lovers. Sir Richard won the case, but was awarded derisory

Natalie Dormer as Lady Worsley in *The Scandalous Lady W.* (Alamy)

damages of just one shilling, less than £6 today. His reputation was ruined; the Worsley dynasty doomed.

This was a catastrophic reversal of fortune. Sir Richard had, in 1782, completed the transformation of Appuldurcombe into a sumptuous Palladian mansion. It was filled with Chippendale furniture and priceless artefacts, and set in a vast ornamental park landscaped by Capability Brown. He represented the peak of the Worsleys' wealth and influence, was a privy councillor and, as comptroller of George III's household, very close to the king.

> DID YOU KNOW?
> Edward Elgar, composer of the *Enigma Variations* and symphonies for violin and cello, spent his honeymoon in Ventnor at No. 3 Alexandra Gardens in May 1889. He paid for it with the £5 earned from his *Salut D'Amour,* written as an engagement present to his new wife, Alice Roberts.

Disgrace – and a New Lease of Life for Sir Richard

For a while, Sir Richard tried to restore his reputation, embarking on an extensive Grand Tour of Europe and adding further to the remarkable collection of art displayed at Appuldurcombe. As the *Dictionary of National Biography* entry on him notes: 'Failure in marriage had redoubled his ardour as a collector'. Emma Page, in *Place and Power: The Landed Gentry of the West Solent Region in the Eighteenth Century*, comments: 'Others might be addicted to drinking or gambling; Sir Richard spent all his money ... on *objets d'art*.' He published two expensive catalogues of his collection but, says Page, 'the work did not restore Sir Richard's social power'.

In 1790 he retreated, with his 'housekeeper' – more accurately mistress – Sarah Smith, to Sea Cottage, a hideaway he built on the Undercliff at St Lawrence. Here, a new phase opened up in Sir Richard's life, one which brought him happiness and contentment.

At St Lawrence he found a new focus, developing Sea Cottage into a far grander gentleman's retreat – the model for many more such coastal houses built in the nineteenth century – and renamed it Marine Villa. Stewart Abbott, in *The Isle of Wight, c. 1750–1840* says: 'Residence in this location was seen as living on the edge; a truly sublime experience.'

Sir Richard embellished the grounds with small classical temples and planted a vineyard, which failed in the salt-laden sea air. Abbott writes:

> Worsley's Sea Cottage retreat removed him from his more accessible and public Appuldurcombe, his island seat. His choice of an ideal site was no problem as he owned most of the Undercliff ... All Worsley's aesthetic knowledge and Grand Tour experience were used to create an elegant marine villa ... a fashionable cottage residence that had the function of a mansion.

Marine Villa, Worsley's hideaway.

A nineteenth-century sketch of the villa and garden temples.

St Lawrence Well.

W. Cooke in his 1812 publication *A New Picture of the Isle of Wight* records the garden buildings: 'The model of the Temple of Neptune at Corinth contains an orangery and conservatory: and the pavilion below the lawn is fitted up in a captivating style of the purest modern taste, as a banqueting room, or saloon.'

Cooke records two inscriptions, painted on the walls in the pavilion, which illustrate Worsley's desire to create a retreat:

> And this our life exempt from public haunt,
> Finds tongues in trees; books in the running brook;
> Sermons in stone – and good in everything.

And:

> Forsake the tawdry tinsel of the great;
> The peaceful cottage beckons a retreat,
> Where true content each solid comfort brings –
> To Kings unknown, and favourite of Kings!

However, the Isle of Wight was becoming a popular destination for the moneyed classes, and Marine Villa was written up in the guidebooks produced for those keen to explore the

island's topographical delights and present their cards at the fine houses, in expectation of a guided tour. Worsley's home attracted many such callers, but Sir Richard wanted to be left alone, and placed a notice on the gate: 'The Sea Cottage is not shew'd'.

Worsley also built a housing for St Lawrence Well, an ancient point of veneration for pilgrims just outside Marine Villa. Sir Richard enclosed the well, fed by a stream tumbling down the hillside, in a Gothic Revival well house complete with ornate wrought-iron gates, which his successor, Lord Yarbrough, kept locked, leading one disappointed pilgrim to pin a verse to the gates, which read:

> This Well, we must own, is most splendidly placed,
> And very romantic we think it;
> The water, no doubt, too, would pleasantly taste
> If we could but get at it, to drink it!

The well, which by some accounts was enclosed by Lord Yarborough rather than Worsley, still stands beside the narrow lane, which was then the main road from Ventnor to St Lawrence, but the waters now run past it down the hillside.

Appuldurcombe's Forgotten Squire, Robert Williams

When Sir Richard died, childless and heavily in debt, in August 1805, Appuldurcombe went to his niece, Henrietta, who married Charles Pelham, Lord – later Earl – Yarborough, Commodore of the Royal Yacht Squadron at Cowes. He and his son, who inherited on his death in 1846, had little interested in Appuldurcombe, only using it intermittently. Their ownership brought a lean period for the inhabitants of Wroxall, whose craftspeople and traders no longer received lucrative orders from the great house.

> **DID YOU KNOW?**
> All Saints Church in Godshill has a feature that is unique in Britain. It is the Lily Cross, a fifteenth-century wall painting that shows Christ crucified not on a cross, but on a lily. Once known as the Budding Cross, it was whitewashed over at the Reformation, and only rediscovered in the nineteenth century.

The substantial, walled Appuldurcombe Gardens on the edge of the estate, which had provided the house with fruit and vegetables, were no longer needed. In 1851 this market garden, plus other land and a vinery, were rented by a villager, Henry Bull, owner of the village grocery. From then on, the estate's produce went to his shop.

It was not until 1855, when house, estate and treasures were sold to Robert Williams, a rich London lawyer, that Appuldurcombe's – and Wroxall's – fortunes were revived. Williams first ran the house as a hotel and, from 1870, as a school. Appuldurcombe was once more central to the life of the village, and Williams was welcomed as the new squire.

Appuldurcombe Gardens Holiday Park.

Caravans in the walled garden.

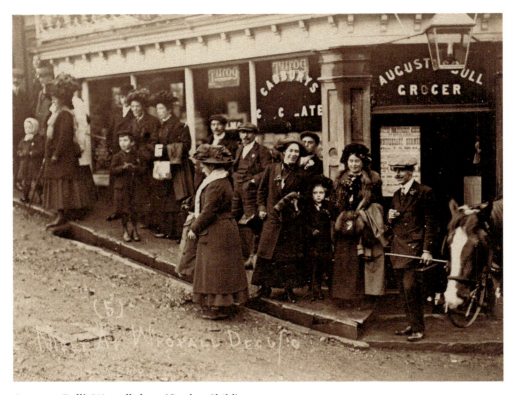

Augustus Bull's Wroxall shop. (Gordon Child)

Henry Bull, who happens to be my great-great-grandfather, passed his Appuldurcombe Gardens smallholding, and his village shop, to his son Augustus. Julia Bishop, in *A History of the Bull Family*, spoke to Augustus's granddaughter Marie Swallow, who remembered:

> I first became aware the whole estate belonged to Squire Williams when one Christmas a super two-storey dolls' house arrived for me – from the squire! Always in the spring there was a terrific upheaval at grandma's home, (even the horse was polished) because the squire was coming to stay and was to drive around the mansion and farms. I think I can truthfully say no weekend passed in my childhood but grandfather took me or I went on my own to the house.
>
> The house and estate were my life for twenty years, I loved every part of it and as my great-grandparents and grandparents had lived at Appuldurcombe Gardens for two generations I was steeped in its history.
>
> Around 1870 the house was used as a young gentlemen's college, most of them being trained for the army ... There were about 100 boys and when my great-grandmother [Sarah Bull] died, the whole school followed her funeral cortege from the gardens to Ventnor cemetery.

Augustus Bull's daughter Selah, who married Bert Holdaway and ran the village drapers, remembered: 'My father's stores in the village were often visited by the boys … they loved their village tuck shop … and always hoped to be in time for the hot cakes!'

The vegetable gardens now house Appuldurcombe Gardens Holiday Park, and forty static caravans are set out within the walled garden.

Crumbling Memorial to the Forgotten Squire

Robert Williams followed the tradition of the Worsley family by being buried in fourteenth-century All Saints Church in the village of Godshill. However, unlike the many generations of Worsleys, who have grand monuments within the church, Williams' tomb is hidden away in the far corner of the churchyard.

Its obscurity is perhaps fitting for Wroxall's last, largely forgotten squire. His Gothic mausoleum is badly neglected. It has lost its pitched slate roof, and the upper part of one side wall has crumbled away. There is nothing on the inscriptions to connect Williams with Appuldurcombe, but a plaque commemorates both Robert and – poignantly – his infant son Heriot, who died five months after his father in November 1862. It reads: 'For of such is the kingdom of heaven'.

All Saints, Godshill.

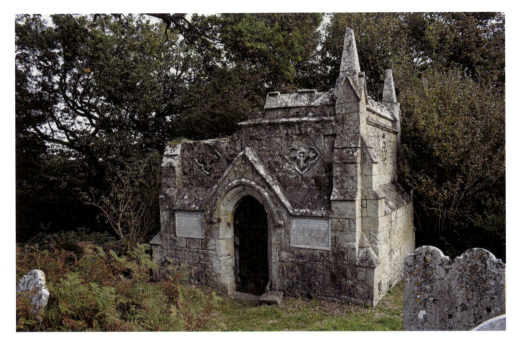

Robert Williams' tomb at All Saints is sadly neglected.

The Destruction of Appuldurcombe

The twentieth century was hard on Appuldurcombe. It lay empty from 1909, except during the two world wars, when it was used as a barracks. Then, in 1943, it fell prey to a crippled German Dornier bomber. Its crew knew they were going to crash and, to have any hope of surviving the impact, they had to first drop the sea mine that they carried. The mine exploded just west of the house, blowing out the windows and causing the roof to fall in. The Dornier crashed into St Martin Down, killing all four crew. However, they didn't quite take Appuldurcombe with them. It survives as a preserved, largely roofless shell in the care of English Heritage.

DID YOU KNOW?
There are traces on the Isle of Wight of an audacious plan to supply fuel to the D-Day invasion force as they stormed inland from the beaches of Normandy. Operation PLUTO (Pipe-Lines Under the Ocean) involved laying a pipe from the mainland, across the island and over the seabed to France. The pipe is visible beside the path in Shanklin Chine. Two fuel pumps were hidden at Brown's Golf Course, Sandown, one in the present tearoom, the other in a fake ice cream kiosk. Sadly, PLUTO only supplied a fraction of the 1 million gallons a day it was intended to pump.

7. Faith on the Isle of Wight

Down the ages, saints, religious Nonconformists and pioneers have found the Isle of Wight a tolerant place in which to practise their faith, and fertile ground in which to sow the seeds of belief.

Lot's Wife: The Missing Needles Rock

Today, the four rounded pillars of the Needles, which jut out into the Solent at the far western point of the island, do not seem particularly well named. They are not, after all, very needle-like. However, there was once a fifth, much sharper-pointed needle among them, which stood in the present gap, with two outcrops on either side of it. It fell into the sea during a particularly violent storm in 1764.

This rock was called Lot's Wife, after the woman in Genesis who disobeyed God's warning and watched the destruction of Sodom. She was turned into a pillar of salt as punishment while her husband and children were allowed to escape.

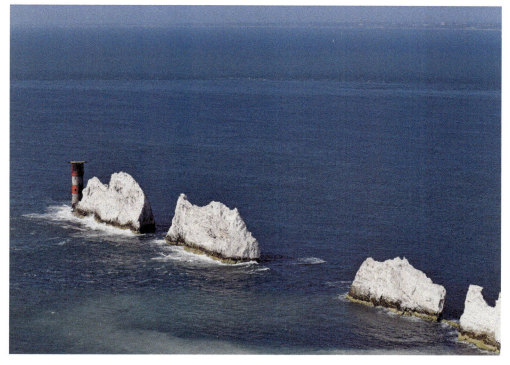

The Needles.

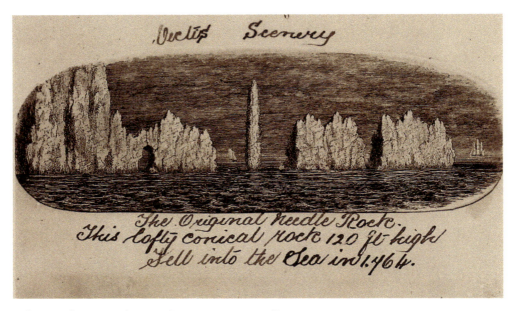

A drawing from 1759 showing the now-missing needle.

The Long Stone of Mottistone, sacred to the Druids. (Debnigo under Creative Commons)

The geological explanation for the Needles' shape is that this is a chalk outcrop, the strata of which was heavily folded into a vertical ridge many millions of years ago, which runs right across the island from Culver Cliff in the east, forms the Needles, then continues under the sea to the mainland, where it reappears as Ballard Cliff near Swanage, Lulworth Cove and Durdle Dor.

To the Druids, in around 600 BC, the Needles may have been a sacred site – one of three on the island – known as the pinnacle of Ur. The other sacred sites were the oak grove of Hexel, now submerged beneath the waters of Brading Harbour, and the Long Stone of Mottistone, a pillar of iron sandstone, which is the oldest example of man's work on the island. A horizontal stone close by may have been a sacrificial altar.

During the Dark Ages the Isle of Wight was the pagan kingdom of Wihtwara, ruled by King Arwald. In 685 it was invaded by a West Saxon nobleman called Caedwalla, who vowed that – if he should prevail – he would give a quarter of the island to the Christian God.

He kept his promise, in 686 allowing St Wilfred, a Benedictine monk, to baptise any islanders who wished it, making this the last area in England to be Christianised. Wilfred built the island's first church, at Brading, where St Mary the Virgin now stands.

St Boniface, Bonchurch

The other great missionary reputed to have visited the island is St Boniface, to whom the old church at Bonchurch is dedicated, and the downs behind the village named. The present old church is Norman, built just four years after the conquest, and its dedication suggests there was a Saxon church on the site. Boniface was one of the foremost medieval missionaries, and is known as the Apostle of the Germans. By some accounts he is the originator of the tradition of the Christmas tree.

St Boniface old church, Bonchurch.

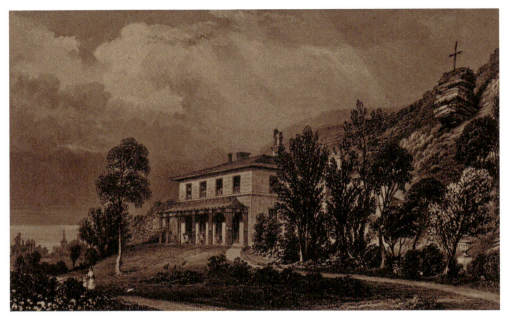

Pulpit Rock, Bonchurch, in a nineteenth-century sketch.

Pulpit Rock's remains today. (IslandEye)

There are local legends that St Boniface preached to Bonchurch fishermen from a towering pillar of stone called Pulpit Rock. When the area was developed in the mid-nineteenth century, the villa built closest to it in The Pitts was named Pulpit Rock after it. At the time, the summit of this rock pillar could be reached via a bridge from the main cliff face, from which it stood a few yards distant.

DID YOU KNOW?
According to local legend, St Catherine's Oratory was built on the summit of St Catherine's Hill in 1328 by Walter de Godeton, Lord of Chale, as an act of penance after he stole wine from a shipwreck in Chale Bay. The wine came from a French monastery, and Godeton was threatened with excommunication unless he built the oratory and beacon. It is known as the Pepper Pot. Next to it is the Salt Pot, the base of a 1785 lighthouse that was never completed, and is now enclosed by a barbed-wire-protected fifties radio station.

St Catherine's Oratory.

Pulpit Rock featured on postcards in the 1880s, but disappeared from maps in the middle of the last century, following its collapse. It does still exist, but as a shadow of its former self, tumbled down and leaning against the foot of the cliff face.

A curious Egyptian-style mausoleum in the churchyard at the 'new' Victorian St Boniface in Bonchurch commemorates the developer of Pulpit Rock and other villas, Henry Leeson. Leeson, a physician and lecturer in Forensic Medicine at St Thomas's Hospital, London, owned much of Bonchurch, and built a number of houses here.

Mary Toms, the Bible Christian Missionary to the Island

Mary Toms was a rare thing in the 1820s: a female itinerant preacher. So, when she stepped up onto a borrowed chair on the Esplanade in East Cowes to pray and sing hymns, she quickly attracted a crowd. Mary was twenty-seven, and a member a new Nonconformist church, an offshoot of Methodism called the Bible Christians.

She had come across the church in her native Cornwall, where it originated, and her gift for preaching earned her the title 'Female Agent' and a mission to evangelise on the Isle of Wight. Mary wrote:

> On Sunday morning I went to East Cowes ... and though it was wind and rain I borrowed a chair and sang *Come ye sinners poor and wretched* and it was not long before scores assembled coming from every part of town, some laughing some talking, but I spoke on and had not proceeded far when the tears began to flow from my eyes and many others.

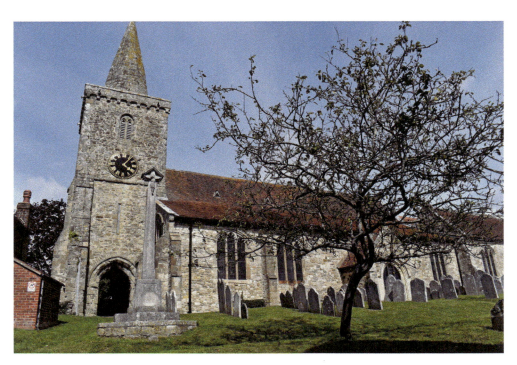

St Mary the Virgin, Brading.

The graves of Mary Toms and husband William Warder at St Mary the Virgin.

The Bible Christian, now Methodist, chapel at Brading.

Mary, with the power of her words and belief, had won an indifferent, perhaps hostile crowd around. It was something she would do repeatedly in the coming weeks as she toured the island at a frenetic pace, preaching three or four times each Sunday, at villages two to four miles apart, taking bible classes in between, and winning many converts along the way.

The Bible Christian message was readily received by farm labourers and the poor, but there was also fierce opposition to this upstart church among the squires and Anglican clergy, and hostility to women such as Mary.

Bible Christian services were often held in secret, in cottages, because farm workers feared that if their attendance got back to their employers they would lose their jobs and be evicted from their homes. At a cottage being used for worship in Chale, opponents smeared the gates with tar and excrement and piled tubs of filth against the door. Mary and other women preachers were attacked and, according to Revd J. Woolcock, in his book *A History of the Bible Christian Churches on the Isle of Wight*, 'were often in danger of losing their lives from the heavy missiles thrown at them by enraged men'.

> DID YOU KNOW?
> In the garden of St Thomas of Canterbury Catholic Church in Cowes is a small marble monument to two young priests, Robert Anderton and William Marsden, who were executed at the town in 1586, during the time when Catholicism was outlawed. They were sailing in secret to England from the continent when a storm forced their boat to dock on the island. They were arrested after being overheard praying for the safety of the ship.

The reason for all this fear and anger was that the Bible Christians challenged the cosy alliance between the Established Church of England and the landed gentry, both of which fought back hard. Joan Mills, in *The Female Itinerant Preachers of the Bible Christian Church,* reports that Mary Toms was accused of making a riot, and a magistrate, urged on by a clergyman, ordered her arrest. The parson wanted Mary off the island, but wiser heads prevailed and the charge was dropped. Woolcock explains:

> The clergy offered the strongest possible opposition to female preaching – speaking against it writing against it ... It was a serious matter with some, when these women evangelists could draw larger numbers to hear them preach than the clergy could.

Beneath the Anglican clergy's fear of Mary Toms lay jealousy. They could only dream of drawing such vast and engaged congregations. Woolcock gives the example of how Mary Toms was received in Wroxall:

It was one of the first places occupied by the Bible Christians as a preaching post. Dear old sainted friend Edmonds [a parishioner] remembered hearing his mother say, after she had been to one of Mary Toms' services here, that 'the pa'son couldn't praich a bit like her'.

James Thorne, who preached in Wroxall shortly after Mary, encountered the ad-hoc arrangements that the church had to adopt in the early days. Woolcock reports:

During the Rev Jas Thorne's first visit to the island he preached at Wroxall in a bakehouse belonging to Mr Bull, and also slept at Mr Bull's house. He said judging from his congregation, 'I perceive the people are very ignorant, but many of them listen with great attention to the word, while their tears bedew their cheeks.' The Wroxall Society was well rooted and grounded from the beginning, and has steadily prospered.

Mary Toms, having spread the word across the island, was persuaded to give up her itinerant mission by William Warder, who she met in Brading while founding the Bible Christian society there. They married in 1824, and William became preacher at the chapel. Mary lived in Brading until her death in 1850, and is buried in the churchyard at St Mary the Virgin, there being no non-conformist cemetery.

Quarr Abbey

Another religious group that found the Isle of Wight a fertile ground were the Benedictine monks of Solesmes in France, who left that country at the start of the last century in the face of religious intolerance. Initially they rented Appuldurcombe House (the subject of chapter 6) in Wroxall, erecting a prefabricated iron church alongside the Palladian mansion.

Quarr Abbey.

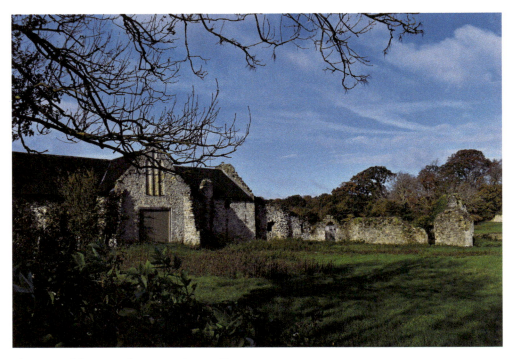

The ruins of the pre-Reformation Quarr Abbey.

The iron church was sent from France by rail and steamer, and was opened in March 1903. However, relations with the Benedictines' landlord, Robert Williams, were not good. The house was poorly maintained and, when Williams refused to pay for essential repairs, the abbot decided the community should move once again.

DID YOU KNOW?
Brading vicar Leigh Richmond wrote a book about Elizabeth Wallbridge, *The Dairyman's Daughter*, chronicling her conversion to Methodism and her death, aged thirty, from consumption. The book influenced authors including Charles Dickens and Charlotte Bronte, and sold 10 million copies in forty languages. Elizabeth lived at Arreton, 3 miles from Newport, and her grave there became a pilgrimage destination for thousands, including Queen Victoria.

In 1907, Diana Wood writes in *Quarr Abbey Newsletter*, the monks bought 240 acres on the east of the island on the site of the twelfth-century abbey of Quarr, which had been demolished by Henry VIII. They set about building a new monastery and church here. One of their number, the gifted architect Dom Paul Bellot designed a striking church built

from two million Belgian bricks, of which Elena Curti, in *Fifty Catholic Churches to See Before You Die,* writes:

> Were it not for the cross on the conical bell tower, Quarr's abbey church might be a mosque or a Moorish fortress. Here the humble brick has been employed to produce an idiosyncratic building of solemn beauty ... The bricks have a warm and varied colour palette of red with tinges of pink, orange and yellow. [Bellot] used them to create patterns and combined them sparingly with local stone for decorative features (Quarr takes its name from 'abbey of the quarry').

Building was completed in just eighteen months by Captain Henry Linington, of Wroxall, who also won the contract to transport the iron church from Appuldurcombe to Quarr.

In 1912, when the new permanent church was completed, the iron church was offered free to any Catholic community in need of one. Fr Jean-Baptiste from the Cistercian community at Woodbarton, Kingsbridge, Devon, responded to an advertisement in *The Tablet*, and the church was moved once again. The Cistercians left Woodbarton early this century and their monastery was converted into apartments, but the iron church has survived, albeit put to a new secular use: it houses a very swanky swimming pool.

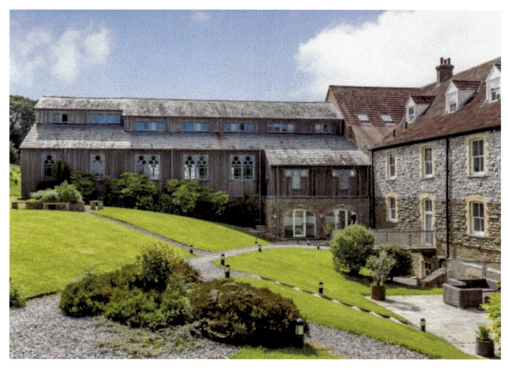

The iron church was moved to the Cistercian monastery at Woodbarton, Devon. (Strutt and Parker)

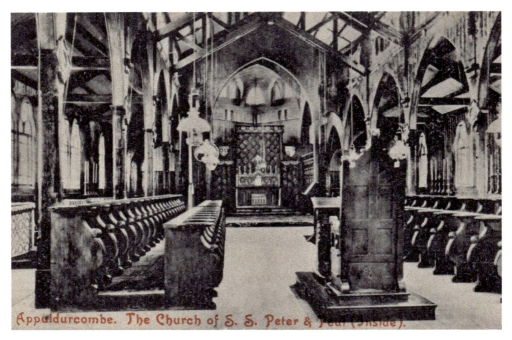

The interior of the iron church on a nineteenth-century postcard.

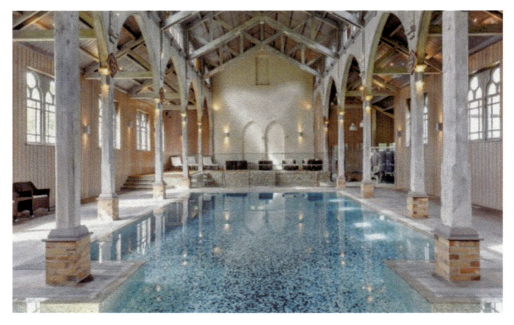

The iron church interior today, housing a swimming pool. (Strutt and Parker)

8. The Island's Great and Good

In the second half of the nineteenth century the great and the good flocked to the Isle of Wight, drawn partly because Queen Victoria made it her main residence. The poet laureate Alfred Lord Tennyson made his home at Freshwater, as did the pioneering photographer Julia Margaret Cameron. Many other literary figures holidayed here, from Dickens to Keats, Jane Austen to Longfellow.

Nowhere else would you find such a distinguished crowd. William Makepeace Thackeray's sixteen-year-old daughter commented: 'Everybody is either a genius, or a poet, or a painter or peculiar in some way'. Many of the well-to-do aspired to a life here, fuelling a flood of speculative building of Marine Villas – coastal residences for gentlemen – especially along the Undercliff between Bonchurch and Blackgang.

However, there was a hugely distinguished forerunner to all these 'fashionables', as the poet Gerard Manley Hopkins referred to them. He was the eminent architect John Nash.

John Nash on the Isle of Wight

As personal architect to the Prince Regent, later George IV, John Nash did more to change the face of London than anyone since Christopher Wren. He is famous for the Marble Arch and Buckingham Palace, and for conceiving – with James and Decimus Burton – the aristocratic garden city of Regent's Park, and Regent Street. He also realised the Prince's vision for the Royal Pavilion in Brighton.

A bust of architect John Nash. (David Castor under Creative Commons)

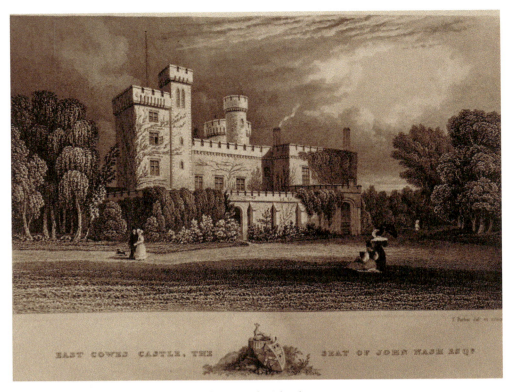

Nash's East Cowes Castle, his main residence on the island.

Hamstead House, built by John Nash as a more private residence.

Far less well known is Nash's architectural contribution to the Isle of Wight, partly because his greatest achievements have – sadly – been demolished. Yet Nash was once a hugely prominent figure, playing a key role in the public and social life of the island. He built two grand residences for himself, neither of which have survived, and a clutch of churches and civic buildings that are still standing, albeit radically altered in several cases.

East Cowes Castle and the Hamstead Estate

In 1798, John Nash suddenly became very wealthy, moving into a palatial new London residence and buying 30 acres of farmland above East Cowes, an area now delineated by Old Road, New Barn Road, York Avenue and Castle Street. Here he built himself a splendid Gothic mansion called East Cowes Castle.

At the same time, he married a poor but beautiful twenty-four-year-old called Mary Anne Bradly, who was twenty-two years his junior. Nash acknowledged no children of his own, but over the next ten years the couple adopted five babies that were said to be orphans of a distant relative of his wife, with the surname Pennethorne. There was much speculation that these might actually be illegitimate children of the Prince Regent. If true, this arrangement would have added a further powerful bond between the two men.

Nash added to East Cowes Castle over the next thirty-seven years, creating a fairy-tale Gothic confection with castellations, turrets and towers, a grand Regency staircase, a large picture gallery in which to hang his Turners and other masterpieces, and a 50-yard-long conservatory.

In the first decade of the nineteenth century, Nash designed twenty more country mansions, enabling him to add another floor to East Cowes Castle, and also buy a second substantial estate on the island, centred on Hamstead Farm near Shalfleet, to the west of Cowes. Here he created a retreat where he could escape attention; a house variously described as a shooting box and a romantic villa, with a seven-storey-tall round tower that offered panoramic views over the Solent.

Here he established himself as a successful gentleman farmer – making his 1,000 acres highly productive – and a benevolent squire. The Women's Institute's *Isle of Wight Village Book* records:

> Nash was a generous benefactor of Shalfleet, and employed thirty paupers from the Poorhouse to help reduce the very heavy poor rate. In 1833 he gave eighteen acres to provide employment for the poor. He had a big brickyard beyond the Salterns on the west side of the estuary, and the manager's house stood overlooking the creek.

Nash is also credited with building the first railway on the Isle of Wight. The Hamstead Tramway was a 2-mile narrow-gauge line that Nash had constructed to connect Hamstead Quay and his brickworks with the house he was creating. Trucks were pulled by horses, and the line was torn up once the house was completed.

Nash's Surviving Island Buildings

Nash built St James's Church beside East Cowes Castle, although only the tower now remains as he intended. Across the Medina in West Cowes, he built St Mary's Church where, again, only his tower survives unaltered. He may also have built Northwood House, the mansion behind St Mary's, which was commissioned in around 1799 by the City financier George Ward.

Nash certainly built that mansion's Church Lodge, with its portico and Doric columns, which stands to the south of Northwood House beside St Mary's, and Debourne Lodge, at the south-west entrance to the 230 acres of parkland.

Nash also built two civic buildings in Newport: the Town Hall in the High Street in 1816 and the Guildhall in St James's Square in 1819. He also built Holy Trinity in Bembridge in 1820, which, alas, according to English Heritage, 'collapsed because it was built of the friable Bembridge stone' and had to be rebuilt.

DID YOU KNOW?
Charles Dickens brought his family to Winterbourne House, Bonchurch, in the summer of 1849. He wrote the first six instalments of David Copperfield here, in a first-floor room overlooking the sea, and was joined by John Leech, Punch cartoonist and first illustrator of *A Christmas Carol*, who stayed at Hill Cottage (now Hillside Cottage) in Bonchurch Shute.

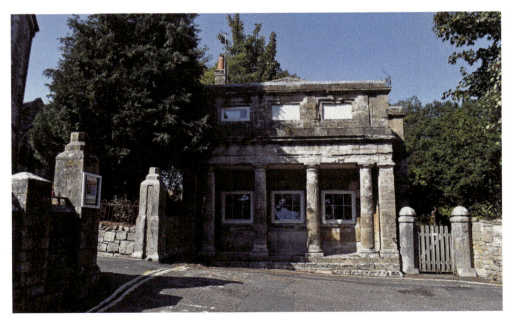

Nash-designed Church Lodge, and the entrance to Northwood House.

North Lodge, Old Road, a rare surviving element of East Cowes Castle. (Razzladazzla under Creative Commons)

John Nash's tomb at St James's Church, which he designed.

Decline, Debt and Nash's Island Buildings Today

Nash was to suffer a profound reversal of fortune on the death of George IV in 1831. He fell right out of fashion, was investigated for cost overruns at Buckingham Palace, and retired to the Isle of Wight. Yet he was not entirely ostracised. In 1831 the twelve-year-old Princess Victoria, who was holidaying at Norris Castle – the grounds of which adjoined those of East Cowes Castle – visited Nash's home and laid the foundation stone of St James's.

Four years later Nash died, aged eighty-four and deeply in debt, and was buried in a tomb tucked at the foot of St James's tower. His coffin was taken there at night to prevent his creditors seizing the body. Mary, his widow, was forced to sell up, and moved to the Hamstead estate along with the five Pennethorne children.

One of them, James Pennethorne, had worked in Nash's architectural practice, and continued to work on the island, including at Northwood House. Mary Nash died in 1851, after which Anne and John Pennethorne remained at Hamstead. The house was sold, after the last surviving Pennethorne died, in 1923.

Little remains of Nash at either location. East Cowes Castle fell into decline and was demolished in 1963, the land used for housing. The architectural historian Nicholas Pevsner described this as 'the most serious architectural loss suffered on the island in the last hundred years'. The sole surviving elements are the castle's Nash-designed gatehouse, North Lodge in Old Road, now a private house, and the ice house, now buried beneath a mound of soil for conservation purposes. A small green plaque on the wall just down from St James's, in Church Path, records: 'This wall is a remnant of East Cowes Castle'.

The clock from East Cowes Castle, now in Carisbrooke Castle's museum.

Nash's Guildhall in Newport.

One item from the main house escaped the demolition: the clock that stood on the tower was removed and placed in storage. Today, restored to working order, it is on display at Carisbrooke Castle's museum.

Hamstead House was largely rebuilt in the late nineteenth century, and demolished after being severely damaged while used as a training ground for invasion forces during the Second World War. Woodcote Cottage, which stands in the grounds and is believed to have been designed by Nash, survives.

Steephill Castle

Many of the other grand houses built across the island, a number of them inspired by the style Nash developed in Cowes, have also failed to survive, among them Steephill Castle.

The American patent medicine entrepreneur and advertising pioneer John Morgan Richards was so captivated by Ventnor and seaside life – he said it 'instantly claimed our delighted souls and held them captive' – that he bought Steephill Castle in 1903. The castle, built in 1833, was a castellated Regency mansion with towers and turrets that borrowed heavily from Nash's vision of the ideal seaside residence.

Ironically, for the man credited with introducing the cigarette to Britain, Richards's castle was on the St Lawrence Undercliff, virtually next door to the Royal National Hospital for Diseases of the Chest, where many inmates were suffering from the effects of smoking, although the connection was not made at the time.

> **DID YOU KNOW?**
> Gentlemen's residences were built right along the Undercliff, often on unstable ground, nowhere more so than at Blackgang. A whole string of marine villas was built below Gore Cliff in the 1840s. All but one has since slipped into the sea.
>
> The exception is a house originally called Five Rocks, but now the Rumpus Mansion, a 'house of horrors' that is among the attractions at the Blackgang Chine amusement park. The park, founded by Alexander Dabell in 1843, has undergone constant reinvention as coastal erosion has nibbled away at it, but it remains Britain's oldest theme park.

In the days of Steephill's original owner, the local landowner John Hambrough, guests at the castle included Queen Victoria and Prince Albert, and European royalty such as the Empress of Austria and her sister, the former Queen of Naples.

Steephill became a hotel in 1903, then a school during the Second World War, and was demolished in 1963. Its grounds are now covered by Ventnor Park and a housing estate, but the original castle gateway on Park Avenue, the stables and coach house are still standing.

Just a year after the castle was demolished, the Royal National Hospital closed, made obsolete by the development of drugs to treat tuberculosis. Its row of 'cottages' – actually grand Gothic houses for inmates – were demolished to make way for Ventnor Botanic Garden.

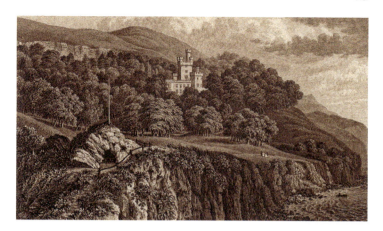

Seephill Castle, now demolished.

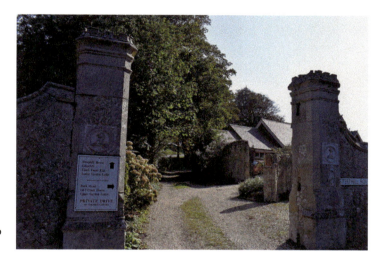

The surviving gateway to Steephill Castle.

Farringford, Tennyson's house at Freshwater.

Farringford House, Freshwater

Farringford was built in 1802 as a fairly simple Georgian house, but in 1823 John Hambrough bought it and gave it a makeover that presaged what he would do a decade later when he built Steephill Castle. Farringford was transformed into a Gothic Revival fantasy, with medieval battlements and colonnades. Doors and windows acquired Gothic arches; shutters and interior panelling and walls got Gothic motifs; and a Strawberry Hill Gothic porch was added. It was grand and romantic.

Little wonder, then, that when the very grand, very romantic poet Alfred Lord Tennyson saw Farringford in 1853, he fell in love with it. Queen Victoria's poet laureate first rented the house, then bought it three years later. Much of his most memorable poetry – including 'Maud', 'The Charge of the Light Brigade' and 'In Memoriam' – was written here and is inspired by the landscape of west Wight. Tennyson wrote of Farringford:

> Where, far from noise and smoke of town
> I watch the twilight falling brown,
> All round a careless-ordered garden,
> Close to the ridge of a noble down.

He built up a salon around him including the photographer Julia Margaret Cameron, who bought two houses on the fringe of Tennyson's grounds and joined them with a Gothic tower, creating Dimbola, and adding a gateway in her garden so Tennyson could visit whenever he liked. The two families combined for evenings of music, poetry and drama.

Tennyson was inspired by classical and Arthurian mythology. Cameron – one of the most significant portraitists of the nineteenth century – created soft-focus allegorical images portraying characters from mythology, Christianity and literature, as well as portraits of famous Victorians.

Visitors to Tennyson and Cameron included the Pre-Raphaelites William Holman Hunt and John Everett Millais, and the authors Lewis Carroll, Edward Lear and Charles Kingsley.

Tennyson relished life at Freshwater, walking daily on the downs that have since been named after him, and wintered at Farringford until his death in 1892. The house remained in the Tennyson family until the 1940s, then became a hotel until, in 2009, Farringford was bought by art historians Rebecca FitzGerald and Martin Beisly, and underwent a period of extensive renovation. It is now run as a historic house, museum and hotel. The Julia Margaret Cameron Trust bought Dimbola in 1993, and it is now a museum and gallery dedicated to the photographer.

Bibliography

Abbott, Stewart, *The Isle of Wight, c.1750–1840: Aspects of Viewing, Recording and Consumption* (Southampton: University of Southampton, 2006)

Ackroyd, John, *The Ackroyd Collection* http://woottonbridgeiow.org.uk/ackroyd/index.php

Anon The Women's Institute's Isle of Wight Village Book www.woottonbridgeiow.org.uk/wibook/shalfleet.php

Anon, *A Unique Set of Island Heroes* (London: Classic and Sports Car, 2020) www.classicandsportscar.com

Anon, Beatles Bible www.beatlesbible.com/songs/ticket-to-ride

Anon, Hidden Heroes https://iwhiddenheroes.org.uk/category/hidden-heroes/headline-heroes

Anon, *Proceedings of the Congress* (Isle of Wight: British Archaeological Association, 1855)

Anon, Writer Raymond Allen reflects on Some Mothers Do 'Ave 'Em success islandecho.co.uk/writer-raymond-allen-reflects-on-some-mothers-do-ave-em-success

Bishop, Julia *A History of the Bull Family from 1770 to 2000* (Abingdon: privately printed, 2000)

Chapman, Alan, *England's Leonardo* http://www.roberthooke.org.uk/leonardo.htm

Chivers, Tom, 'Britain Hasn't Had a Rocket in Half a Century. Now the Black Arrow is Back', *Air and Space Magazine* (Washington DC, 2019)

Cook, William, *Bonchurch, Shanklin & the Undercliff, and Their Vicinities* (London: Leggatt, Hayward, & Leggate, 1849)

Cooke, William, *A New Picture of the Isle of Wight* (London: Baker, 1812)

Curti, Elena, *Fifty Catholic Churches to See Before You Die* (Leominster: Gracewing, 2020)

Firstenberg, Arthur, *The Invisible Rainbow* (Vermont: Chelsea Green, 2017)

Foulk, Ray, with Foulk, Caroline, *Stealing Dylan from Woodstock* (Surbiton: Medina, 2015)

Foulk, Ray, with Foulk, Caroline, *The Last Great Event* (Surbiton: Medina, 2016)

Girvan, Ray, JS Blog https://jsbookreader.blogspot.com/

Grydehøj, Adam, and Hayward, Philip, 'Autonomy Initiatives and Quintessential Englishness on the Isle of Wight', *Island Studies Journal* (California, 2011)

Hooke, Robert, Isle of Wight History https://www.iwhistory.org.uk/RM/hooke/sggg.htm

In writing this book, I have read or consulted the following books, publications and websites:

Marconi, Degna, *My Father, Marconi* (Toronto: Guernica, 2001)

McInness, Robin, *Paradise Lost? The Lost Buildings of the East Wight* www.downtothecoast.co.uk/uploads/paradise-lost-expl-heritage-loss-in-ew-final-report.pdf

McLeod, Angela, *The Brilliant Stage: The Story of Frances Walsingham* (London: Matador, 2014)

Medland, John, *The Isle of Wight and the Birth of Radio*, (Newport: Newport Beacon, 2007)

Short, Colin ,and Mills, Joan, *The Female Itinerant Preachers of the Bible Christian Church* https://dcxok27cd6yp9.cloudfront.net/wp-content/uploads/2015/04/The-Female-Itinerant-Preachers-of-the-Bible-Christian-Church.pdf

Spencer, Charles, *To Catch A King: Charles II's Great Escape* (London: William Collins, 2017)

Tomkins, Charles *A Tour to the Isle of Wight* (London: Kearsley, 1796)

Williams, David L *Made on the Isle of Wight* (Stroud: History Press, 2016)

Wood, Diana, Quarr Abbey Newsletter Summer 2017 www.quarrabbey.org/uploads/Quarr_Abbey_NewsletterSummer_2017.pdf

Worsley, Sir Richard, *The History of the Isle of Wight* (London: A. Hamilton, 1878)